Brain Darts

THE ADVERTISING DESIGN OF TURKEL SCHWARTZ & PARTNERS

ROCKPORT

First published in the
United States of America by:
Rockport Publishers, Inc.
33 Commercial Street
Gloucester, Massachusetts 01930-5089
Telephone: (978) 282-9590
Facsimile: (978) 283-2742

Distributed to the book trade
and art trade in the United States by:
North Light Books, an imprint of
F & W Publications
1507 Dana Avenue
Cincinnati, Ohio 45207
Telephone: (800) 289-0963

Other distribution by:
Rockport Publishers, Inc.
Gloucester, Massachusetts 01930-5089

ISBN 1-56496-565-1

10 9 8 7 6 5 4 3 2 1

Designed by Turkel Schwartz & Partners

Printed in China

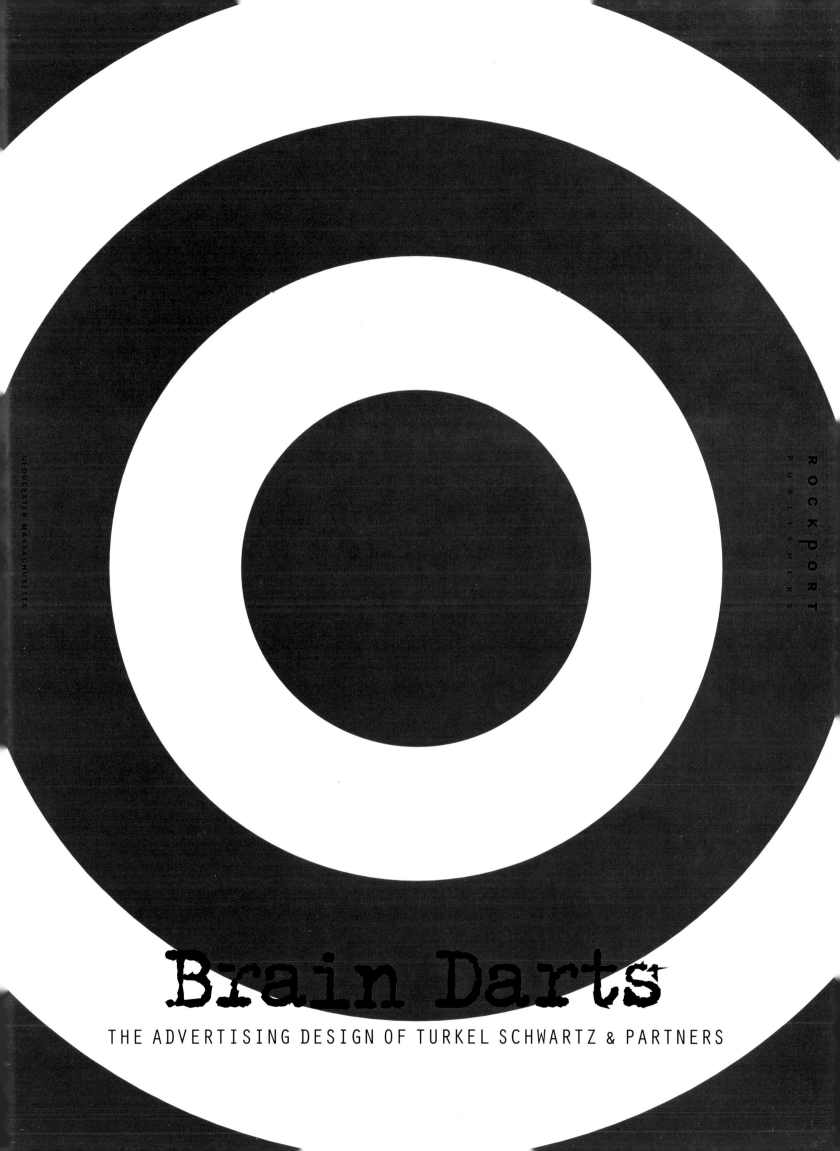

GLOUCESTER MASSACHUSETTS

ROCKPORT PUBLISHERS

Brain Darts

THE ADVERTISING DESIGN OF TURKEL SCHWARTZ & PARTNERS

TURKEL SCHWARTZ & PARTNERS IS AN ADVERTISING AGENCY.

Our clients pay us to get people's attention. And so in 1983 we started creating messages that would catch our clients' customers' attention and present them with an idea that they'd want to think about and remember — no matter how busy or distracted they were.

Remember those chase scenes in old cartoons? Sooner or later the action would wind up in a long hallway lined on both sides with doors. The characters would go in and out of the doors, slamming them each time, until you had no idea who was where. Before too long, the characters didn't know where they were either, and started passing themselves in the hallway before running back into the rooms they came out of.

More and more it seems that life is like that — we're bombarded by thousands of advertising messages each day, all of which are screaming louder and louder to get our attention. And while all of that noise is being hurled at us, we're dealing with our kids' needs, our parents' wants, and our own expectations. After a while, we don't know which door we're behind either.

Contrary to popular opinion, as we grow older our knees are not the first things to go — our patience is. Clearly something has got to give.

We needed to overcome this. And we found that simple, powerful, often humorous messages would break through the clutter and really stick in the minds of the people we aimed them at, regardless of their distractions.

Brain Darts were born.

THE DIFFERENCE BETWEEN SCULPTURE AND PAINTING.

Both sculpture and painting are art forms. They both require enormous amounts of skill. Both can be used realistically, abstractly, or almost anyway in between. And both can create incredibly moving pieces of art.

As similar as these art forms appear to be, they are actually completely different. As you'll see, painting and sculpture are exactly opposite art forms — painting is additive; sculpture is subtractive.

Think about it — a painter sets up his canvas and proceeds to put things, generally paint, onto the surface. Regardless of the technique, whether the painter is as precise as a photo-realist and applies the paint with single-hair brushes or is as frenetic as Jackson Pollack and hurls the paint at the surface, the result is intrinsically the same. The painter continues to add paint to the face of the canvas until he's done. The resulting image is his art.

The sculptor, on the other hand, removes things until she is left with her art. This reduction process refines the original shape of the medium into whatever it is that the artist wants to represent.

Have you ever noticed that when sculptors talk about their work, they generally refer to their process as freeing the image from the marble, the wood, or whatever? "The driftwood already knew what it wanted to be." Or "the bird was in the piece of stone, it was my job to free it."

Not convinced? Have you been to see the *David* in Florence? Do you remember what was on either side of the hallway leading to the great masterpiece? Big blocks of partially carved marble that Michelangelo began to work on but abandoned. Apparently, as he got into each piece of rock he realized that David simply wasn't there.

It's the same with advertising. Most of what you see is like painting — it's additive. Agencies and clients add headlines, photographs, body copy, and logos to the surface of their ad until they're convinced that they've included everything that could ever interest their potential customer. Then, perhaps they add a few more things, such as hours of operation, locations, and a few discounts just to make sure they have not missed anything.

Unfortunately, what they ultimately miss is their intended target's attention.

Great advertising, on the other hand, is a lot like sculpture. The people creating it decide what they want to say and then remove every single extraneous element from the message until they are left with the single sharpest point that will get their intended target's attention. They create Brain Darts.

Simple as that?

Well, not really. While less is sometimes more, less is often actually less. Or, as Frank Lloyd Wright said: "Less is more when the more isn't very good." Subtraction is just not as easy as addition; in fact it's damn hard. And while it may be intoxicating and fulfilling to pare down a message to its simplest elements, what often happens is that the spine gets pulled right out of the message along with everything else.

So, judicious paring is essential. As is an understanding of the most important part — the essence — of what a product can deliver and what a customer wants.

That, in a nutshell, is what creating Brain Darts is all about — finding the simplest, most powerful message that can talk to the consumer in a way that they'll understand, appreciate, remember, and act on.

Easy? No.

Exciting? Certainly.

Successful? Absolutely.

Come take a trip through this book and look at some of the Brain Darts Turkel Schwartz & Partners has created over the last 15 years. Sometimes we'll explain them to you — when the work was created for a specific market or a unique product — sometimes we'll let them stand on their own, just as they do out in the real world.

8

IT'S NOT ABOUT
US GETTING BIGGER.

IT'S ABOUT THE WORLD
GETTING SMALLER.

On June 24, 1998, AT&T and TCI joined forces, forever
changing the way we communicate.
By becoming bigger we've become even smarter --
making your world easier.

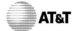 AT&T

THE POSSIBILITIES ARE ENDLESS.

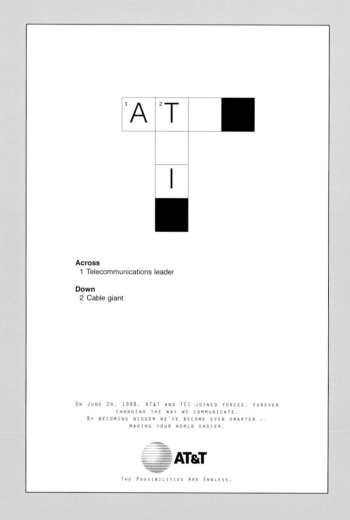

Across
1 Telecommunications leader

Down
2 Cable giant

On June 24, 1998, AT&T and TCI joined forces, forever
changing the way we communicate.
By becoming bigger we've become even smarter --
making your world easier.

AT&T

THE POSSIBILITIES ARE ENDLESS.

"The public image of AT&T is getting more complicated than ever…Here in the U.S., the *Wall Street Journal* asked some of the advertising world's creative minds to dream up campaigns to make an AT&T-TCI combo sound likable." So said Sally Beatty, staff reporter for *WSJ*.

1 > 2

On June 24, 1998, AT&T and TCI joined forces, forever
changing the way we communicate.
By becoming bigger we've become even smarter --
making your world easier.

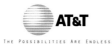 **AT&T**

The Possibilities Are Endless.

TALK, FAX, WATCH, LISTEN, LAUGH, FIND, CRY
SURF, ACCESS, QUESTION, TELL, SECURE, CONVERSE
DEFINE, LEARN, CONFESS, GAIN, PROTECT, SCREAM
SEARCH, SMILE, SPEED-DIAL, COMMUNICATE, INTER
PRET, GUIDE, ENJOY, STUDY, ENTERTAIN, DISCOVER
TYPE, EXAMINE, LOG-ON, HEAR, RELAX, COPY, WORK
ORDER, ROAM, CONSOLE, WITNESS, APOLOGIZE, ABSORB
GIGGLE, SURPRISE, DELIGHT, SEND, PREDICT, DIVERT
PLAY, CHARM, VIDEO, ACQUIRE, RECEIVE, MAIL, TEACH
OPEN, CLARIFY, ENTRY, CONFERENCE, TYPE, CREATE
THINK, INVENT, PRODUCE, PROMISE, SEIZE, MEET
EXCHANGE, CONTROL, SAVE, FORMAT, TRANSFER
INSERT, VIEW, TRAVEL, MAGNIFY, FRAME, SCHEDULE
EXAMINE, PEEK, ENJOY, SHARE, FILE, VOICE MAIL, VIDE
CONFERENCE, EARN, DETERMINE, CREATE, SEE, NURTURE
TAKE, POWER, ADMIRE, TRANSFER, EARN, STARE, INVEST
INFORM, LINK, REVEAL, INTRODUCE, SCAN, LEARN, FEEL
MOVE, NEGOTIATE, PONDER, SEND, MOVE, PRINT, SATIS
FY, TRASH, REPLACE, EAT, TRAVEL, DRAW, ADVISE
READ, COUNT, FEEL, ANNOUNCE, DELIVER, STORE
EDUCATE, EDIT, GRASP, CHUCKLE, OBSERVE, NOTE
COMMENT, PRINT, PLAY, SHOW, REVIEW, EVOLVE, CALL
REGISTER, WRITE, INTERACT, CATALOG, EXCHANGE
QUESTION, DOCUMENT, WEB, COLOR, PURCHASE, RECOUNT
FORECAST, ANSWER, STYLE, COMPUTE, RESEARCH, PRESENT
DEAL, ADVISE, COOK, INSTRUCT, RECORD, BUY, COPE
BROADCAST, BUILD, WANT, ANALYZE, PLAN, OPERATE
NEWS, LIVE, DESIRE, FIX, JUSTIFY, GATHER
DESIGN, CHARGE, UNCOVER, KNOW, IDENTIFY, AMUSE
SIMPLIFY, EMBARRASS, PROTEST, LIST, TRADE
QUOTE, GROW, SEEK, CALL, ORGANIZE, REVEAL
INVESTIGATE, DIRECT, FILM, LOOK, UNDERSTAND,

On June 24, 1998, AT&T and TCI joined forces, forever
CHANGING THE WAY WE COMMUNICATE.
By becoming bigger we've become even smarter --
MAKING YOUR WORLD EASIER.

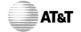 **AT&T**

The Possibilities Are Endless.

"Because this whole thing is so complicated, the companies so big, and the technologies so complex, the idea was to look for icons that can explain it very simply. It was always a paradigm shift. It was always two is greater than one. All of a sudden, that's no longer true." So said us.

The client was a hair salon that couldn't afford to advertise, but couldn't afford not to. Which got us to thinking: when would their customers, hip, South Beach types, care about their hair the most? When they were trying to meet other hip, South Beach types, of course. So we bribed a few club bouncers to put our ads (stickers, really) on the mirrors in the bathrooms of their nightclubs.

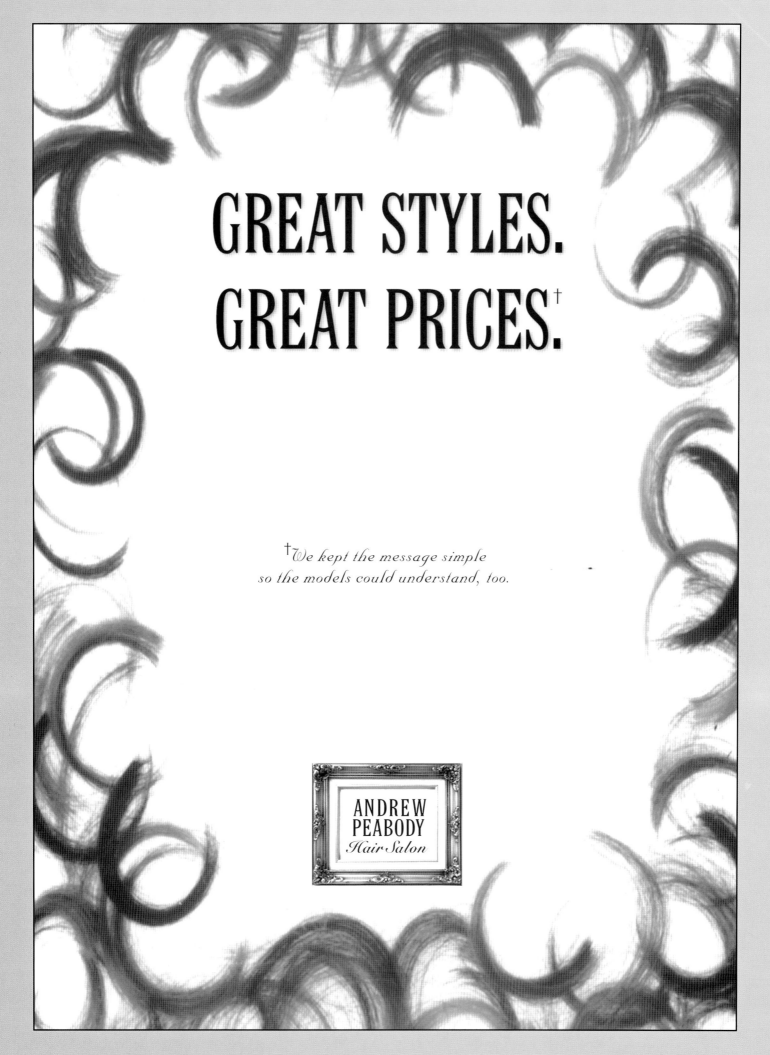

ARCHIVE AMERICA

ARE YOU STUCK IN THE DARK AGES?

STORAGE & RETRIEVAL SERVICE

Once you decide to modernize your record keeping, Archive America's expertly trained staff will work on-site to help your employees select and prepare documents, computer tapes or microfiche for storage in our specially designed containers. Each container is then marked with a bar coded strip and entered into our computer database. Reports are developed to integrate with your filing system and are designed to accommodate your specific requirements. Additionally, in situations where increased selectivity is required, files can be specifically coded and indexed before being loaded into our specially created software management system.

DOCUMENT TRANSFER

Archive America maintains a sparkling fleet of company owned and operated vans available to pick up and deliver your records on a moment's notice. Our service representatives will handle all aspects of the transaction, reducing your firm's efforts to a single phone call. For research or proofing functions, your documents can even be sent to your office via facsimile machine (Fax). Pick up and delivery can be scheduled on an as needed basis or on a regular daily, weekly or monthly route. Your Archive America account service representative will implement a document transaction procedure that perfectly matches the way your firm works.

SECURITY

Documents stored at Archive America's modern warehouse facility are properly protected. Our perimeter security system begins with a fully fenced enclosure and buildings which meet Factory Mutual's strict HPR fire safety standards.

What's more, the buildings' electronic intruder and fire monitors are backed-up by an off-hours guard service. Our security practices include releasing documents only to your firm's designated representatives. And for additional security and anonymity, your cartons and files are completely unmarked except by our computerized bar code, unrecognizable to all but our trained personnel equipped with Archive America's computerized bar code wands.

COMPUTER CAPABILITIES

The same bar code which makes it possible for our staff to quickly and accurately locate and deliver your records also enables us to provide you with a full monthly accounting of exactly which files and documents were accessed, who requested the documents, who received them, and how long they were retained. What's more, our computerized system also tracks all container transfers and records their current locations (our facility or your office). When necessary, Archive America can even break out the storage and retrieval charges by department, associate, partner or client. This monthly statement also shows exactly how much space is being allocated for your document storage, ensuring that you only pay for the space you actually use.

Another cost saving benefit of our software system is Archive America's unique document purging capability. This program permits the orderly management of inventory by alerting your office 60 days in advance of the pre-determined purge date for old or outdated documents. Once we have your written confirmation, Archive America will arrange for the proper disposal of the selected documents and provide a timely, detailed destruction report, saving your firm both time and unnecessary storage charges.

QUALITY ASSURANCE

Our quality assurance program ensure the highest accuracy rate and fastest service times in our industry. Every transaction is checked and rechecked before shipment and delivery so that your firm receives exactly the documents and files requested.

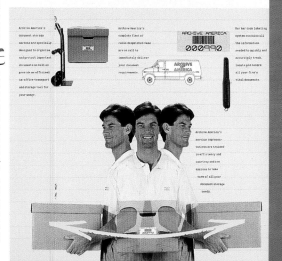

AFFORDABILITY

Compare the security and ease of access offered by Archive America to your present storage system. Compare the cost of sending your key personnel to retrieve confidential files that may take hours to locate with the time necessary to place a phone call to Archive America. And, most importantly, compare the per square foot costs of office or mini-warehouse rental space you are currently using, to the low monthly charges for our efficient, professional service. You will find there really is no comparison.

At Archive America we understand the benefits of providing high quality services while maintaining a favorable price/value standard. That is why we run the most productive and efficient operation in Florida.

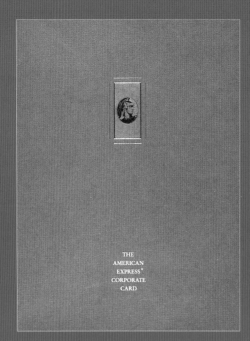

THE
AMERICAN
EXPRESS®
CORPORATE
CARD

THE CORPORATE CARD IS NOW A KEY TOOL IN
THE WAY BUSINESSES MANAGE THEIR INTER-
NATIONAL TRAVEL AND ENTERTAINMENT
EXPENSES. FOR CORPORATIONS, IT HAS MEANT
DETAILED MANAGEMENT REPORTS THAT CAN
LEAD TO SUBSTANTIAL SAVINGS. CUSTOMIZED
BILLING SERVICES THAT IMPROVE CORPORATE
CASH FLOW. AND THE SECURITY AND CON-
VENIENCE OF CARRYING THE CORPORATE
CHARGE CARD THAT HAS EARNED WORLD-WIDE
ACCEPTANCE.

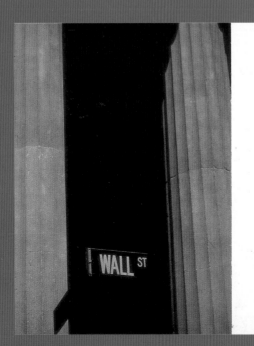

WALL ST

Finally, the Corporate Card reduces
time and money spent on administering
travel and entertainment budgets.
Because most travel expenses can be
charged to the Corporate Card, fewer
man-hours are spent issuing and recon-
ciling cash advances. Our uniform
expense receipts streamline the process
of verifying travel and entertainment
expenses, which means less time spent
auditing expense reports.

A series of checks and balances is built
into the Corporate Card to protect your
company from unauthorized Card use.
You can cancel a Corporate Card at any
time and, by notifying American
Express of a lost or stolen Card, you are
protected from potential financial lia-
bility. Monthly reports documenting
Card usage provide added control over
Card misuse.

The Corporate Card will work with
you to monitor and reduce business
travel and entertainment expenses. We
will help you cut down on the paper-
work and administrative costs of your
business travel and entertainment pro-
gram. And we will let you choose the
billing and payment system that works
best for your company.

THE CORPORATE
CARD OFFERS THE
INTERNATIONAL
TRAVELER THE
SECURITY OF
ACCEPTANCE
WORLDWIDE.

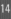

The Hotel Astor is a beautifully restored art deco hotel on South Beach. But before it was beautifully restored, it was our job to create a graphic identity that would live up to the completed project. We did this by using the motifs we found in the property — the terrazzo floors, the patinated walls and the port-holed exterior — and mostly staying out of the way.

VERY HIGH:

VERY LOW:

$199 *Round Trip*

Since their rediscovery in the 1600's, the Mayan pyramids of Guatemala have been accessible, but never at so low a price. What are you waiting for?

Call your travel agent or Aviateca and do a little exploring of your own.

HARD TO PRONOUNCE:

Xunantunich

EASY TO SAY:

$199 *Round Trip*

Why even try to pronounce Xunantunich or Uaxactún when you can see the ancient Mayan wonders with your own eyes? Call your travel agent or Aviateca and we'll show you some tongue twisters that won't strain your wallet.

VERY SCARY:

VERY FRIENDLY:

$**199** ^Round _Trip

Throughout Central America, wondrous Mayan artifacts await your discovery. And at our special round trip price of only $199, there's nothing to be afraid of. So call your travel agent or Aviateca and pack your bags. We'll put a smile on your face without putting a strain on your wallet.

AVIATECA ⬤
The Airline of the Mundo Maya

HARD TO EAT:

EASY TO SWALLOW:

$**199** ^Round _Trip

Next time you have a craving for some Meso-American cuisine, bite into a real bargain. Call your travel agent or Aviateca and take a look at our menu. We'll give you a price you can really sink your teeth into.

AVIATECA ⬤
The Airline of the Mundo Maya

This project was a first for us. The local Advertising Federation
had asked their member agencies to take turns creating the monthly
newsletter. When our turn came, we decided to send out a disk with

an interactive newsletter on it. The real challenge was that way back in 1993 we had just barely started dabbling in the new media and this piece was our baptism by fire. Lucky for us, we didn't go up in smoke.

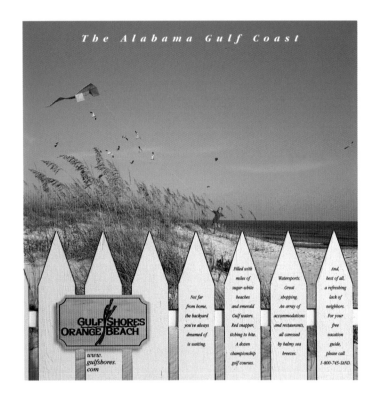

The laid-back Alabama Gulf Coast faced the daunting task of differentiating itself from the nearby Florida Gulf Coast. With less money to spend and fewer attractions, Alabama was at a disadvantage compared to Florida — yet both were competing for the same vacation dollars.

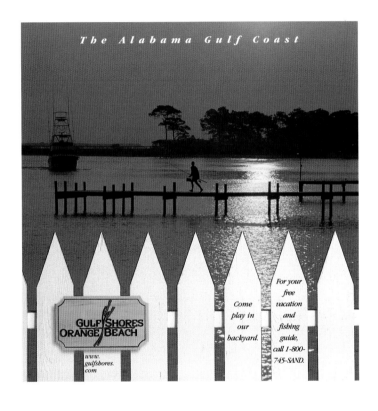

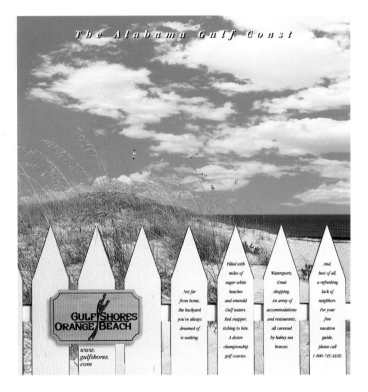

We identified families within driving distance of the Alabama Gulf Coast as our target audience and developed a campaign that struck close to home. Using the motif of a white picket fence in the foreground, the headline read "Come play in our backyard." Record numbers of families did just that.

ACCOMMODATIONS
LOCATION
THINGS TO DO
WRITER'S RESOURCES
GROUPS
OTHER ALABAMA SITES

The Alabama Gulf Coast - Come play in our backyard.

MAP WEATHER

HERE, ON ALABAMA'S GULF COAST
INVADING THOUGHTS DON'T STAY LONG

They are not welcome. Not here.

Our sugar-white shoreline boasts a 32-mile stretch of beach offering plenty of space

in which to dispose of plenty of thoughts.

From the south, emerald green waters crash at your feet.

The waves' cool mist hovers, and a breeze carries it inland.

You peek out from under a lazy eyelid, catch site of the gulls,

and they depart as quickly and quietly as your thoughts.

Leaving you to your breathing and dreaming.

GULF SHORES
ORANGE BEACH

ACCOMMODATIONS
LOCATION
THINGS TO DO
WRITER'S RESOURCES
GROUPS
OTHER ALABAMA SITES

The Alabama Gulf Coast - Come play in our backyard.

ATTRACTIONS EVENTS FISHING GOLF DINING

YOU'VE GOT THINGS TO DO, AND PLACES TO SEE.

Like historic Fort Morgan, famed site of the Battle of Mobile Bay,

where the phrase "Damn the torpedoes, full speed ahead!" was born.

Roam its corridors rich in history.

During summer months, feel the past move forward and take hold of you

during living history lessons. Then retreat.

Go back to breathing and dreaming if you'd like.

But if time allows — and around here, it usually does — there's much to do.

GULF SHORES
ORANGE BEACH

ACCOMMODATIONS
LOCATION
THINGS TO DO
WRITER'S RESOURCES
GROUPS
OTHER ALABAMA SITES

The Alabama Gulf Coast - Come play in our backyard.

BED&BREAKFAST CAMPGROUNDS HOTELS & MOTELS IND. OWNED RENTALS MGMNT COMPANIES

BREATHING AND DREAMING NOT LIMITED TO THE BEACH

Will it just be the two of you?

A romantic bed and breakfast with extra

Do Not Disturb signs may best suit your needs.

Can't find it in your heart to leave the brood behind?

Perhaps a beach house would best fit the occasion. Whatever type of accommodations

your vacation calls for – from deluxe condominiums overlooking the Gulf to

just a regular hotel room – you'll find them here.

All moderately priced. All with plenty of elbow room.

GULF SHORES
ORANGE BEACH

ACCOMMODATIONS
LOCATION
THINGS TO DO
WRITER'S RESOURCES
GROUPS
OTHER ALABAMA SITES

The Alabama Gulf Coast - Come play in our backyard.

MEETINGS TRAVEL AGENTS GROUP TOURS

BREATHING AND DREAMING
MAKES FOR A WONDERFUL GROUP EXPERIENCE

Gulf shores/ Orange Beach has been a most gracious host

to visitors from all over the world. Why do they come?

Most importantly: why do they come back? Choice.

There are plenty of activities to bypass – or be a part of. Bike rides. Arcades.

A waterpark. A zoo. Mini–golf courses for children of all ages, as they say.

Long walks on the beach. Boutiques. Gift shops. Art Galleries. Specialty shops.

All within a mortar's throw from Fort Morgan.

GULF SHORES
ORANGE BEACH

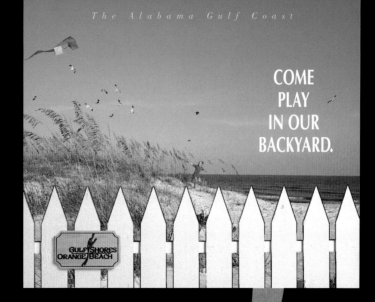

COME PLAY IN OUR BACKYARD.

GULF SHORES ORANGE BEACH

ACCOMMODATIONS

LOCATION

THINGS TO DO

WRITER'S RESOURCES

GROUPS

OTHER ALABAMA SITES

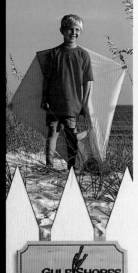

GULF SHORES ORANGE BEACH

The Alabama Gulf Coast - Come play in our backyard.

Once you've traveled just far enough,

you will come to a scenic hideaway

that offers the perfect mix of silence and peace.

Everything quiets. Nature speaks.

And gulls swing from an invisible thread in the sky.

They see you.

Motionless on the sand. Your eyes closed.

Breathing and dreaming.

Breathing and dreaming

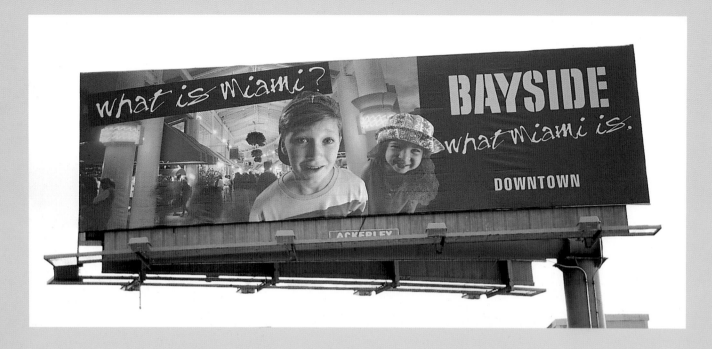

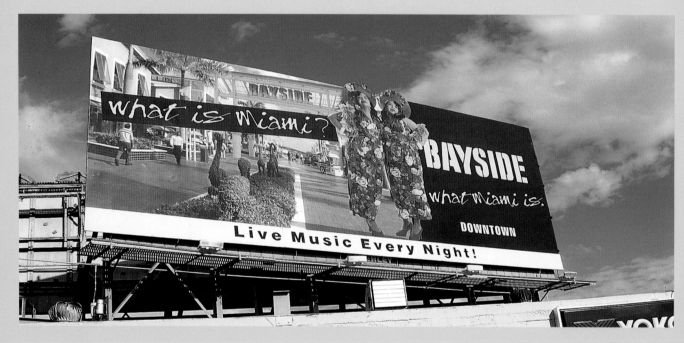

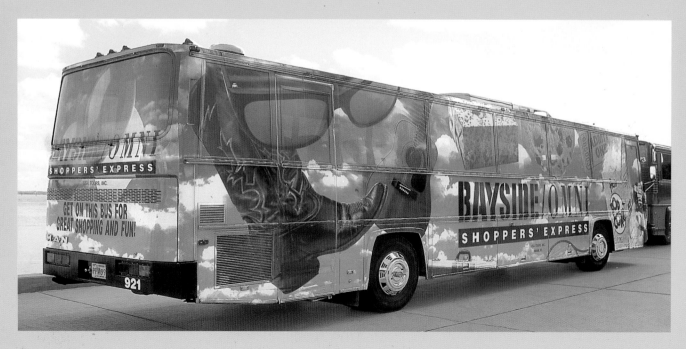

An ergonomically designed bicycle for people with lower back problems.

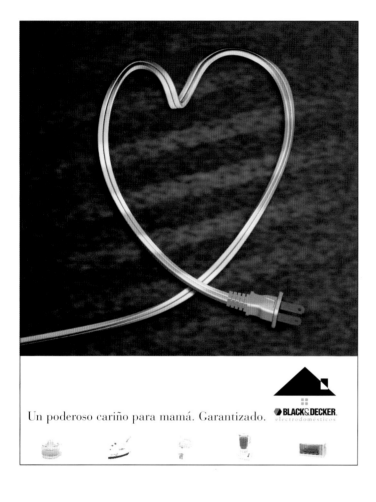

Un poderoso cariño para mamá. Garantizado.

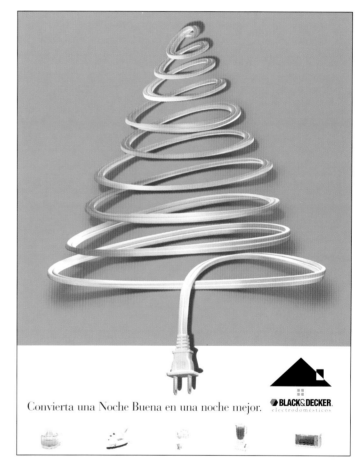

Convierta una Noche Buena en una noche mejor.

Black & Decker Latin America wanted to increase their home-appliance sales. And what better way to accomplish this than by getting men to buy small appliances for their female relatives on special occasions? We knew most men hate to shop for presents. Truth is, we knew they didn't even want to spend time reading ads. They just wanted to get in,

get what they needed, and get out. So instead of boring these fellows with all sorts of factual reasons why they should buy the women in their lives a Black & Decker appliance as a gift, we simply used the products themselves as bait. "Buy me," the products said, "and she'll know you care."

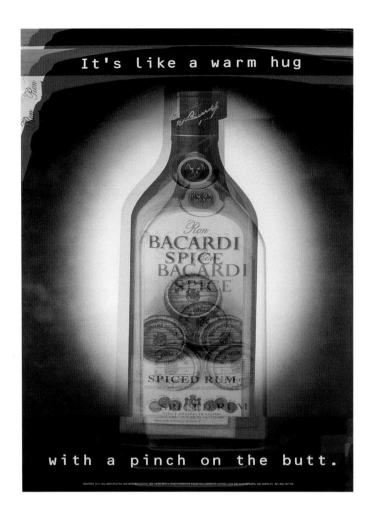

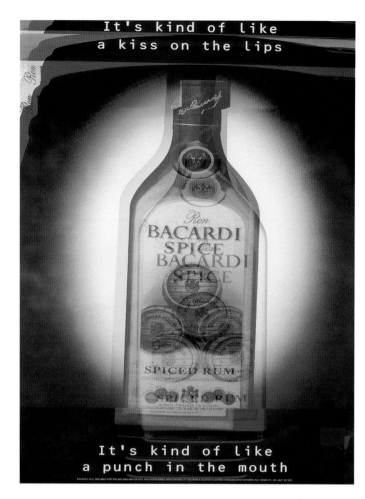

28

Bacardi is a vintage company that has made rum for generations. Amidst a maelstrom of competition, the firm wanted to appeal to a new generation — young adults who would be more intoxicated by a hip image than by the actual product. We developed insightful ads that juxtaposed the smoothness of Bacardi rum with a swift kick in the pants. And that sent our audience running to the nearest bar to order Bacardi by name.

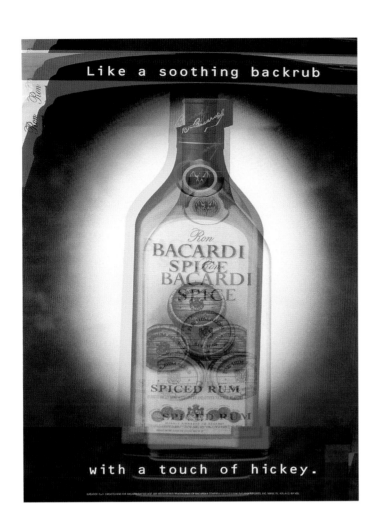

Like a soothing backrub

with a touch of hickey.

I'm in this bar and this guy next to me goes, "I'll have a gimlet." I mean, he's like my age and he's ordering a *gimlet*. That kills me.

It's something different.

So this one time, I went to this bar with my Dad. And he says, try this. I go, "What is this?" He goes, "Scotch." So I tried a little. I didn't like it.

It's something different.

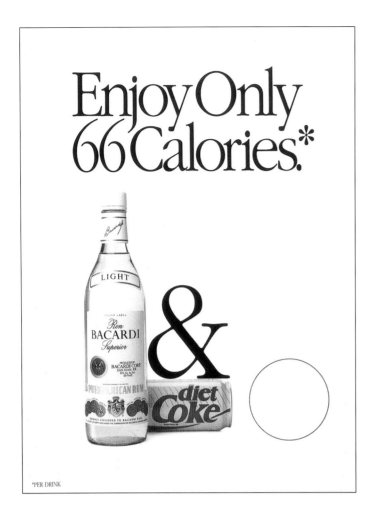

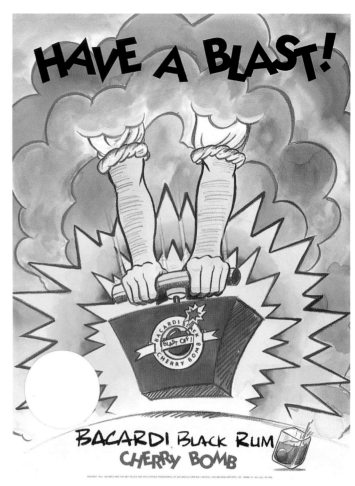

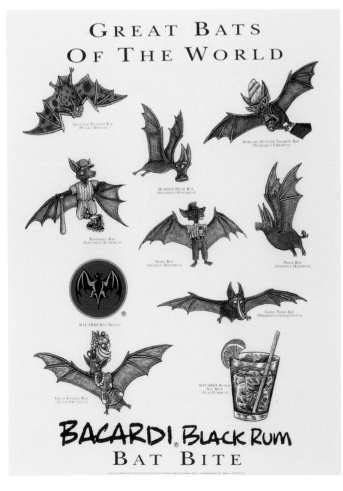

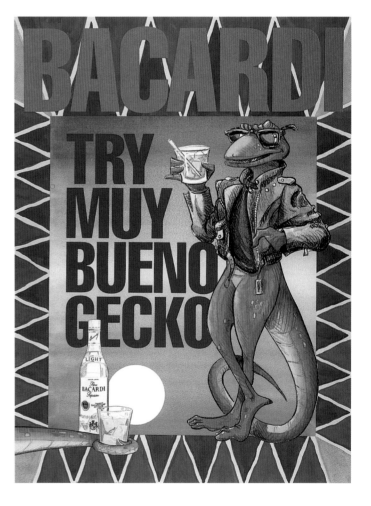

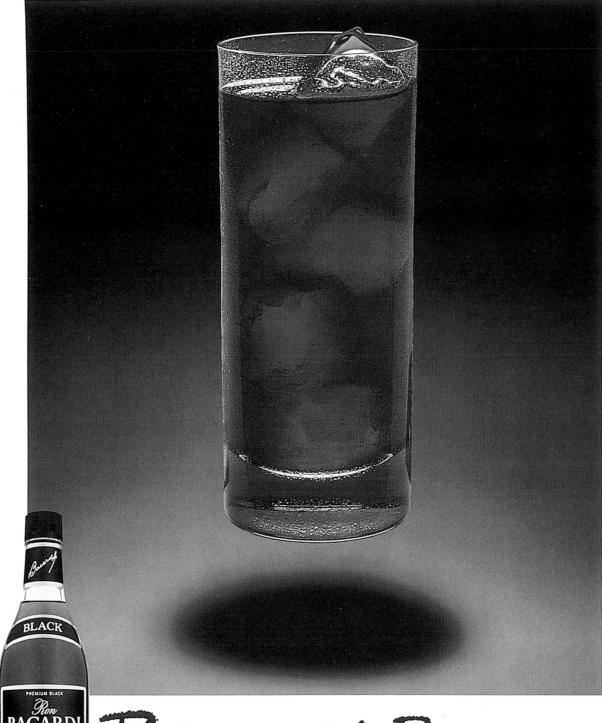

BACARDI. BLACK MAGIC

BACARDI Black Rum · CRANBERRY JUICE · PINEAPPLE JUICE

If you don't think your kids belong in our Jewish day school, don't worry, you're not alone.

At Bet Shira, your kids will learn more than just reading, writing and arithmetic. They'll learn what it means to be Jewish. The way their heritage, history and religion affect their lives. And the lives of those around them.

Please call us at 238-2601 to discuss how our schools can enrich your child's life. Or visit our new sanctuary at our get-acquainted brunch this Sunday around ten a.m. Our doors, and our hearts, are open.

BET SHIRA
The Contemporary Conservative Congregation

For information on membership, day or religious school programs call 238-2601

7500 SW 120th Street, Miami

When we first researched the market and competition for this client we found that most every house of worship used the same three strategies in their ads. The first was pictures of the congregation and copy that talked about the warmth of community and feeling of fellowship they enjoyed; the second was a picture of the religious leader (whether priest, rabbi, or minister) with a promise of expert guidance and spiritual leadership; and the third was either a picture of a little girl with a bird on her finger or an equally insipid photo of a sunset with a caption suggesting that the reader could bask in the glory of a higher power. In this case, our brain dart was to do something different.

THE BOULEVARD

DON'T JUST INVEST IN STOCKS,

BONDS AND MUTUAL FUNDS.

INVEST IN A RELATIONSIIIP.

At the new Charles Schwab Latin America Center on Brickell Avenue, we prefer to call our clients by their names. Not their account numbers. Because knowing who you are and understanding what you need is what Schwab is all about. And the information we provide will make you feel more comfortable and confident about making investment decisions that are right for you. At rates less than full-commission brokers. You'll also have 24-hour service including Internet access. So whether it's 3 A.M. in Caracas or 3 P.M. in Coral Gables, you can get the up-to-date account and investment information you need at the touch of a button. Of course, when you want to talk with us, we're just a phone call away.

FREE Internet Demonstration.
Please call or e-mail international@schwab.com to learn how to manage your investment portfolio online.

Latin America Center Headquarters 1000 Brickell Avenue, Suite 201, Miami, FL 33131 (305) 373-1370
Latin America Center 110 Merrick Way, Suite 1, Coral Gables, FL 33134 (305) 774-4829

Charles Schwab

www.schwab.com

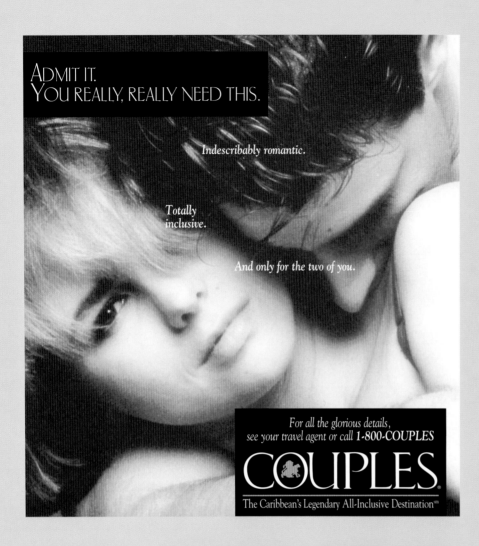
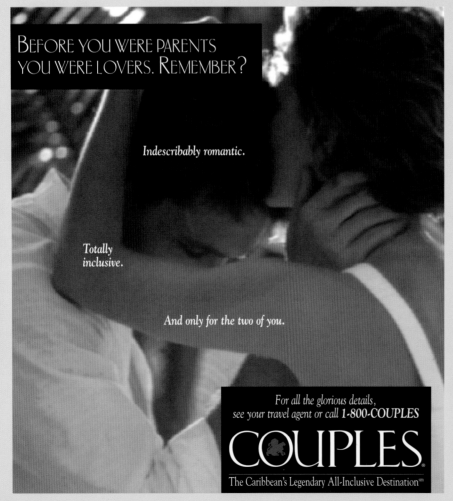
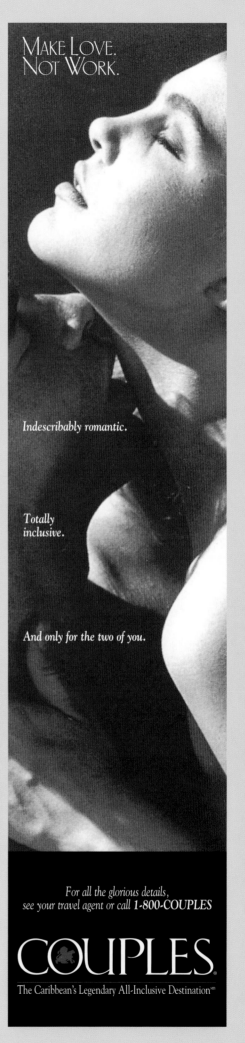

There are plenty of all-inclusive resorts to choose from. And most make it a point to not only spend a lot of money on advertising, but to cram their ads with tons of photos showing smiling people having a good time. We were not about to try to beat the big guys at their own game. Not only because we didn't have the budget, but because we wanted to set Couples apart from the fray. So we took Couples somewhere different. Somewhere more intimate. More relaxed. More in touch with the reasons why couples long to escape the grind of chores, kids, and frantic routines in the first place. The result? Chronic 90%-plus occupancy.

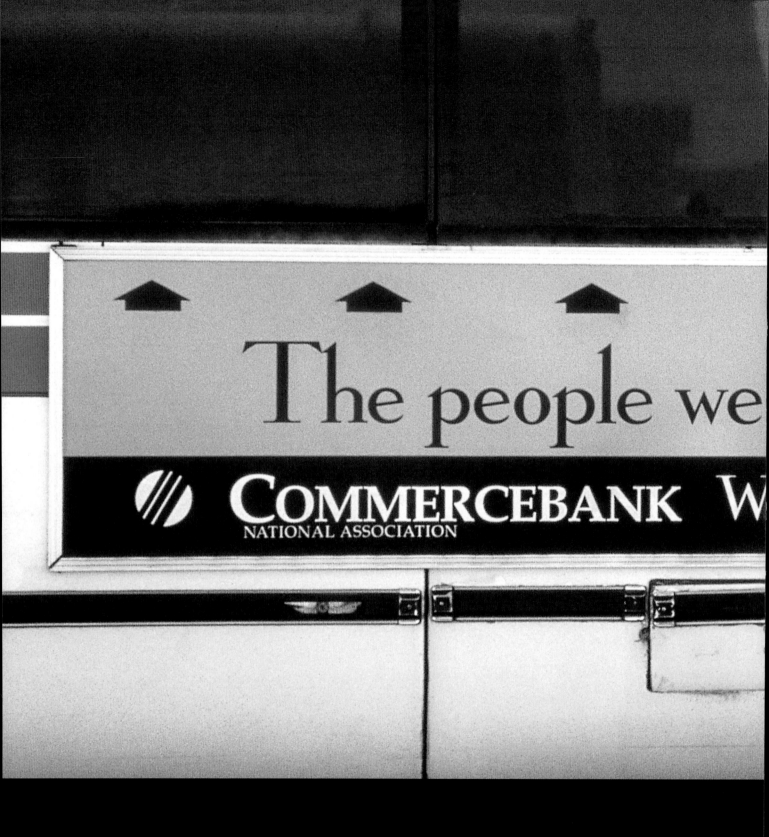

Commercebank was a small bank with very few branches. And very few media dollars to spend. Because people tend to

bank close to home, we introduced our theme: "Commercebank. We're a part of your neighborhood." And we strategically placed advertisements in highly targeted newspapers and

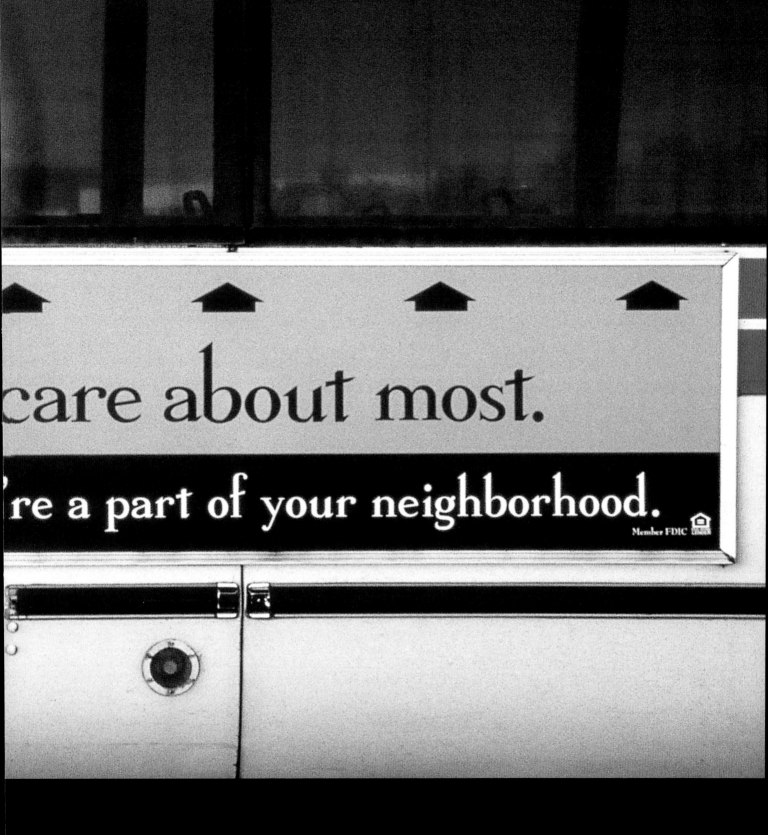

around specific neighborhoods in bus shelters and on buses. As a point of differentiation, we stressed the bank's personal service. And we got that message across effectively in a

world where most banks view their customers as "account holders" instead of people.

Announcing A Cure
For The Common HMO.

If you're sick of HMOs that promise more than they deliver, check into Community Medical Plan. We offer flexible, high-quality health care plans backed by a Provider Network of over 3,000 Board Certified or Board Eligible physicians and 40 hospitals. At premiums that are probably lower than what you're currently paying. For all the details, call **1-800-929-9800 ext. 1288.**

COMMUNITY
MEDICAL PLAN

A CURE FOR THE COMMON HMO℠
3127 W. HALLANDALE BEACH BLVD., SUITE 113 HALLANDALE, FL 33009

Our job was to introduce a latecomer into the already crowded Florida HMO marketplace. So we went on the offensive, taking full advantage of the inherently restless HMO relationships. We positioned Community Medical Plan as a cure for virtually anything the target audience didn't like about their current health plan. The campaign was designed to generate a peak number of inquiries in a short period of time. It did.

CAUTION: Reading these rates can cause intense relaxation and possible euphoria.

AGE	MALE INDIVIDUAL	FEMALE INDIVIDUAL	INDIVIDUAL & SPOUSE	MALE IND. & CHILDREN	FEMALE IND. & CHILDREN	FULL FAMILY
< 30	$73.76	$132.77	$206.53	$169.16	$228.17	$301.93
30 - 39	77.69	124.90	202.60	200.63	247.84	325.53
40 - 49	89.49	115.07	204.56	206.53	232.10	321.59
50 - 54	122.94	152.44	275.37	207.51	237.02	359.96
55 - 59	149.49	161.29	310.78	218.34	230.14	379.16
60 - 64	213.85	212.27	422.90	271.44	267.51	480.92
65 +	230.14	216.36	446.50	283.24	269.48	499.61

INDIVIDUAL PLAN
Charlotte / Lee Counties

Pleasant reading, isn't it? And not only are Community Medical Plan's individual rates really this low, but they're guaranteed for a minimum of 12 months. Oh, and don't worry: we didn't cut costs by cutting corners on coverage. In fact, you'll receive the same flexible, high-quality protection we provide to our group members. With a full range of benefits. And access to our extensive network of top-notch physicians and hospitals. What's missing? Just the stuff you'd rather not deal with in the first place, like deductibles and copayments. To see why affordable individual health care is no longer a contradiction in terms, call us today at **1-800-784-JOIN (5646)**.

COMMUNITY
MEDICAL PLAN

A CURE FOR THE COMMON HMO ˢᴹ

3127 W. HALLANDALE BEACH BLVD., SUITE 113 HALLANDALE, FL 33009

co%op shop

COMMODORE CENTER

CENTRICA

FINANCIAL HOLDINGS

caf-decaf-cafe

THE CENTER FOR
NONPROFIT MANAGEMENT
AT UNIVERSITY OF MIAMI

DeLaRentis®

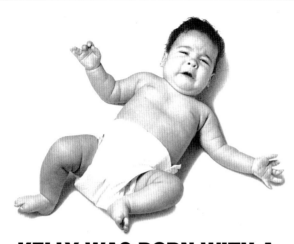

KELLY WAS BORN WITH A SILVER SPOON IN HER NOSE

You may have been blessed with your mother's eyes or the color of her hair. Kelly inherited her mother's drug habit.

Born pathetically underweight and addicted to cocaine, Kelly has endured methadone treatment and, since being in the care of the Children's Home Society, has been nurtured back to health. Today, Kelly's only addiction is to her formula and the affection that every child deserves.

The Children's Home Society offers unconditional hope and comfort to children of all ages. Infants

with AIDS. Children beaten by their parents. Homeless adolescents and retarded children. We even counsel unwed mothers.

You can help us by donating money. Beyond that, we always need diapers, formula, furniture, toys, bedding – even movie tickets. Or you can make a more personal contribution, your time.

Please call 324-1262. We'll show you how to be good influence.

CHILDREN'S HOME SOCIETY OF FLORIDA

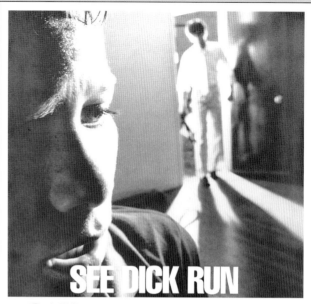

SEE DICK RUN

See Dick hide. See Dick cry. Cry Dick cry. These were the familiar sights in Dick's life. Daily beatings. Nightly pain and confusion. Mornings of reconciliation. Followed by more beatings and lies to cover up cuts and bruises.

Today, Dick is safe, part of the Children's Home Society. Unfortunately, hundreds of other kids like him, have no place to run and hundreds more suffer from other forms of abuse. Infants born with drug addictions. Others born with AIDS. And children simply abandoned by their parents.

The Children's Home Society protects these children.

We also care for adolescents who have been bounced from one foster facility to another, unwed mothers who need counseling and mentally retarded children who need a permanent home.

You can help us by donating money. Beyond that, we always need diapers, formula, furniture, toys, appliances, bedding – even movie tickets. Or you can make a more personal contribution, your time. Don't run from these children. You'll see you can make a difference. Call 324-1262 and find out how.

CHILDREN'S HOME SOCIETY OF FLORIDA

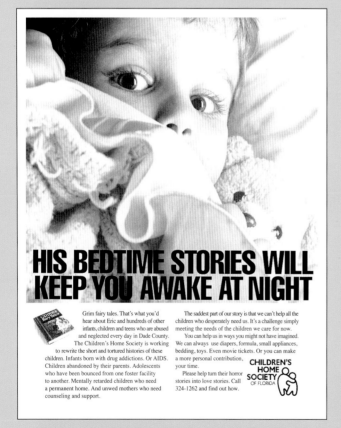

HIS BEDTIME STORIES WILL KEEP YOU AWAKE AT NIGHT

Grim fairy tales. That's what you'd hear about Eric and hundreds of other infants, children and teens who are abused and neglected every day in Dade County. The Children's Home Society is working to rewrite the short and tortured histories of these children. Infants born with drug addictions. Or AIDS. Children abandoned by their parents. Adolescents who have been bounced from one foster facility to another. Mentally retarded children who need a permanent home. And unwed mothers who need counseling and support.

The saddest part of our story is that we can't help all the children who desperately need us. It's a challenge simply meeting the needs of the children we care for now.

You can help us in ways you might not have imagined. We can always use diapers, formula, small appliances, bedding, toys. Even movie tickets. Or you can make a more personal contribution, your time.

Please help turn their horror stories into love stories. Call 324-1262 and find out how.

CHILDREN'S HOME SOCIETY OF FLORIDA

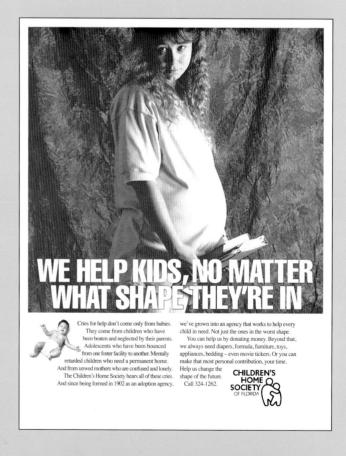

WE HELP KIDS, NO MATTER WHAT SHAPE THEY'RE IN

Cries for help don't come only from babies. They come from children who have been beaten and neglected by their parents. Adolescents who have been bounced from one foster facility to another. Mentally retarded children who need a permanent home. And from unwed mothers who are confused and lonely. The Children's Home Society hears all of these cries. And since being formed in 1902 as an adoption agency,

we've grown into an agency that works to help every child in need. Not just the ones in the worst shape.

You can help us by donating money. Beyond that, we always need diapers, formula, furniture, toys, appliances, bedding – even movie tickets. Or you can make that most personal contribution, your time. Help us change the shape of the future. Call 324-1262.

CHILDREN'S HOME SOCIETY OF FLORIDA

We could've focused on plenty of grim statistics to encourage donations to this worthwhile charity. But our audience had already been bombarded with numbers by other causes. Instead, we put a face to the problem, and sometimes even added a name. Making one point per ad gave each situation more emphasis and impact. And it is hard to turn away when a needy kid makes eye contact.

Our Off-Campus Housing.

Our Cups Runneth Over.

Bet you didn't know that there are more international students from more countries at colleges and universities in South Florida than anywhere else in the world! Neither did a whole lot of our neighbors and fellow Miamians.

So we created a campaign for the Greater Miami Chamber of Commerce that would let people know about all the incredible things our institutions of higher learning offered. Instilling self-respect and fashioning bragging-rights were our goals. An informed and proud population was our result.

Cuando algo tan extraordinario sucede no es necesario gritar. Discovery Networks y la BBC se han uni
Espere noticias pronto o comuníquese hoy mismo con Enrique Martínez en Miami, Florida al teléfono (305) 461-47

This ad was designed to run in a number of broadcast-industry
publications in South America. Looking at other ads in the medium
we found that they were full of eye-popping montages created
from clips of car crashes, *Baywatch* babes, and garish lettering.

ra ofrecer la más increíble programación. América Latina jamás volverá a ser la misma.

en la Argentina con Javier Justo al teléfono (541) 310-0052. ©1997 Discovery Networks América Latina

Because all of the competition's ads looked like someone had
thrown a hand grenade into a crowded discothéque, we presented
an oasis of calm; two black pages with the simple message
"When something extraordinary happens, you don't need to scream."

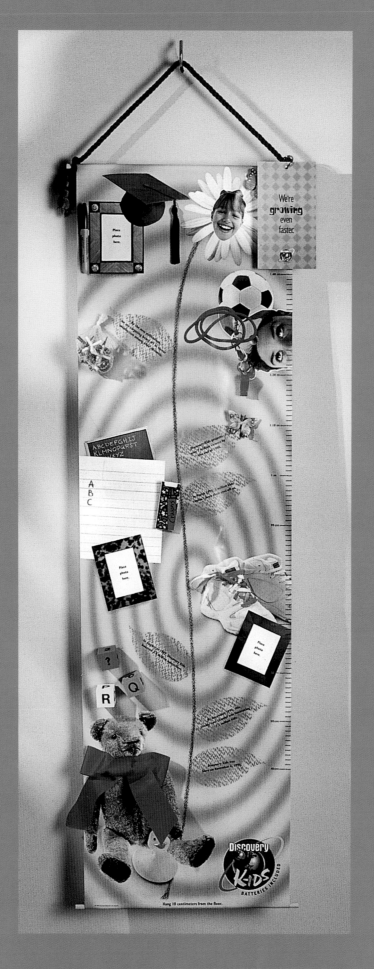

What does a television station actually sell to its customers? Viewers. Advertisers are mostly concerned with the number of viewers who will see their commercials. And because Discovery Kids is the fastest growing kids' network, we wanted a way to show how much they've grown and how many viewers they've attracted. We found the answer in our own childrens' bedrooms. The growth charts that hang on each of our kid's closet doors, with scribbled dates and measurements tracking their lives, were the perfect vehicle to get our message across.

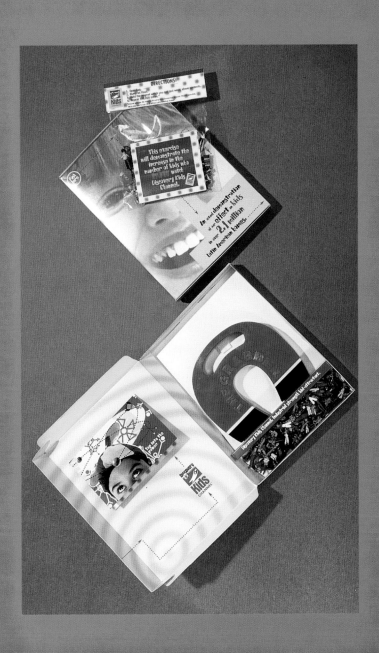

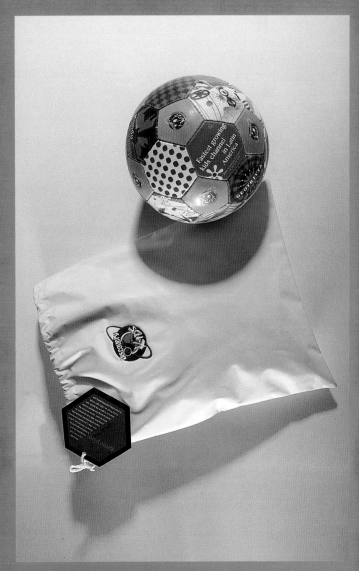

Our goal was to promote the launch of Discovery Kids in Latin America to U.S. media buyers.

Kid stuff?

Not exactly — media buyers are constantly inundated with solicitations of all sorts. Furthermore, before our direct-mail piece could be shipped, Discovery Kids informed us that the number of subscribers had increased by 700,000. We had to come up with a cost-effective way of communicating that fact to our media-buyer audience without revising the already produced piece.

For our first piece, we sent out a blinking box containing an oversized magnet and an overwhelming number of magnetized Lilliputian "subscriber" dolls. We followed up with a piece containing more "subscriber" dolls and a note advising media buyers of our subscribership increase and suggesting that the magnet could also be used on these dolls.

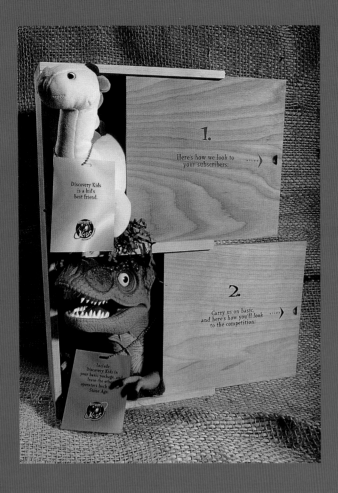

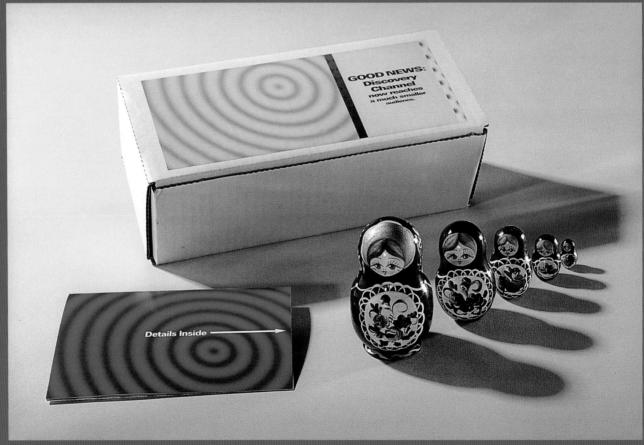

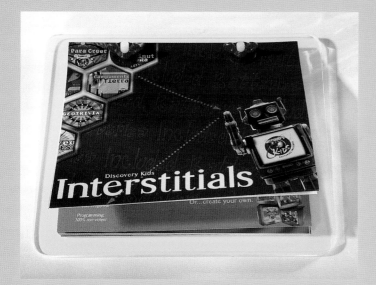

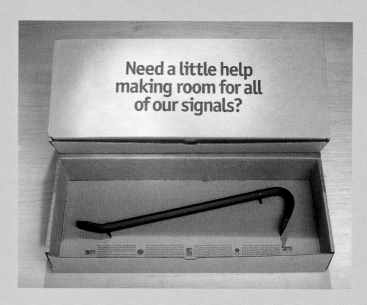

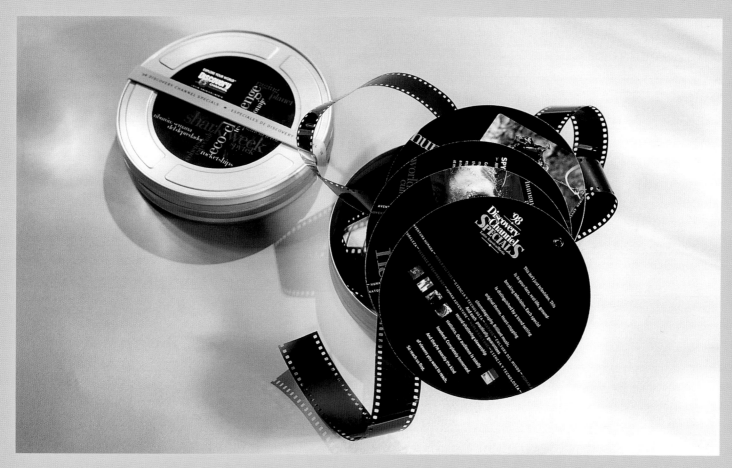

A round brochure packed in a film can atop a bed of — you guessed it — movie film. What better way to communicate that Discovery Channel regularly produces television programs that rival Hollywood's most breathtaking cinematic productions?

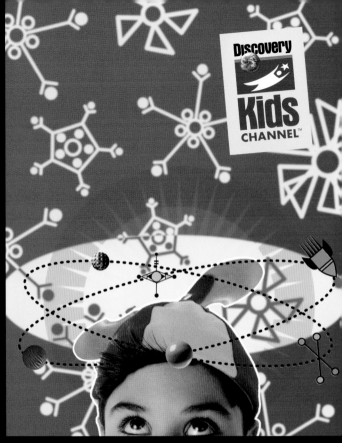

Dear Affiliate:

...come to our quarterly kit for Discovery Kids Channel. In this
...folio you will find all the materials necessary to keep your
...rent and future subscribers informed about the superb
...ldren's programming you have to offer.

...e following materials are contained within this kit:

...RESS SECTION
...eleases that can be submitted to newspapers within your community,
...o stimulate coverage that will inform and excite readers about the
...ine programming available on your system.

...MARKETING SECTION
...A list of principal DKC personnel and telephone numbers. Ad slicks
...for publication in your cable guides and local newspapers. Also
...this quarter, we have included a ready-for-release kid's puzzle to
...incorporate in your cable guide for the entertainment of young viewers.

...PROGRAMMING SECTION
...Here you will find quarterly schedule information and capsule
...descriptions of selected Discovery Kids Channel programs that are
...sure to attract the attention of subscribers and non-subscribers alike.

...ECHNICAL INFORMATION
...ll necessary data you will need to establish satellite communications
...d receive the Discovery Kids Channel signal.

...Discovery Kids Channel, we are committed to helping your system
...w within your community. Utilizing the elements within this portfolio
...eir entirety, we can reach this goal together.

...lways, the Sales Manager remains at your disposal for any
...tions you might have.

...ively,

...very Kids Channel

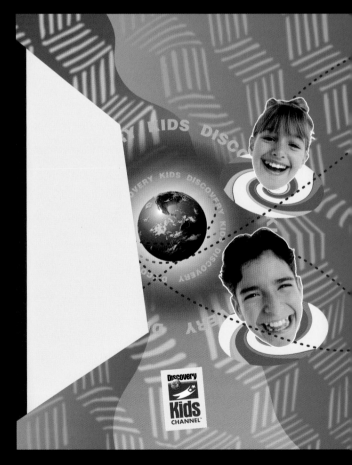

Kids' minds aren't linear. They don't think in straight lines,
...uiet colors, or the tidy rectangles that most adults do.

Nor does this affiliate kit design that introduced Discovery
Kids Channel to potential cable operators.

mooooooooo mooooooooo mooooooooo

Cows chew each meal four times -

As vacas mastigam os alimentos quatro vezes, uma para cada estômago.
Las vacas mastican su comida cuatro veces, una por cada estómago.

once for each stomach.

Most butterflies flap

their wings at a

La mayoría de las mariposas mueven sus alas a una velocidad de 500 aleteos por minuto.

rate of over 500 beats

A maioria das borboletas movem suas asas a uma velocidade de 500 batidas por minuto.

per minute.

More is spent

annually

Gasta-se mais por ano em comida para cachorro do que para bebês.

on dog food than

on baby food.

La gente gasta más en comida para perros que en comida para bebés.

The tailor bird

is named

O pássaro tesoureiro tem esse nome porque tem a capacidade de costurar folhas umas às outras.

for its

ability to sew leaves

El pájaro sastre se llama así porque puede coser hojas.

together.

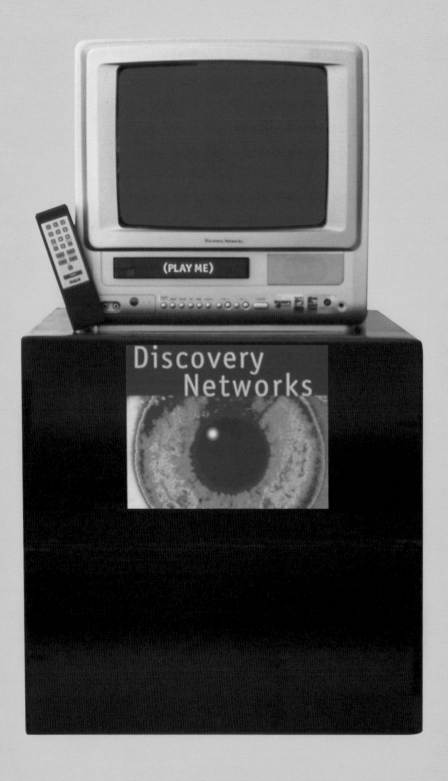

Discovery Channel wanted potential advertisers to see their programming. After all, programming is what is attracting the viewers they're paying for in the first place. Unfortunately, our client had learned that if you simply send a videotape, the recipients leave them on their desks or take them home to record episodes of *Seinfeld*.

Our solution was to make watching the Discovery demo tape unavoidable. And so our audience received a large black box with a solid-gold (painted) TV/VCR inside. All of the TV's controls had been painted over, instead the recipients found a label on the TV's plug that said "PLUG ME" and a label on the tape in the attached VCR that said "PLAY ME." Before they knew it, our audience had seen exactly what we wanted them to see. Maybe they even played it twice.

Discovery Channel presents itself through four genres; nature, human adventure, world culture and science and technology. Our challenge was to present these categories to jaded media buyers in a way they'd look at and remember.

Besides dramatic design, we populated the oversized pages of our brochure with rubber lizards and frogs, moveable mountain climbers, glowing skulls and three-dimensional holograms and let the genres speak for themselves.

I wanna know for sure.

Wild thing,

You make my heart sing,

You make everything,

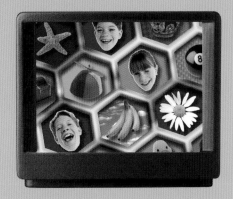

Groovy.

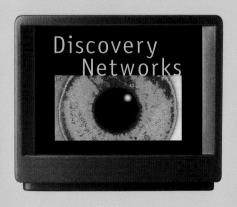

Now, you know for sure.

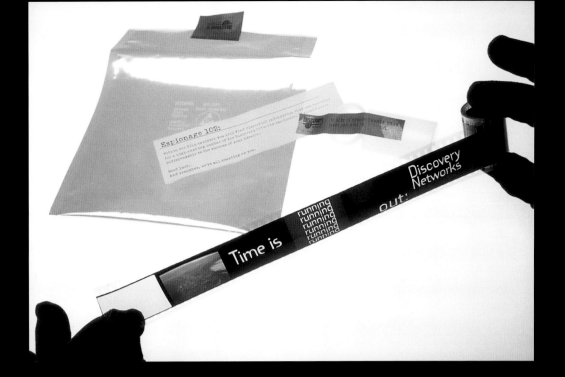

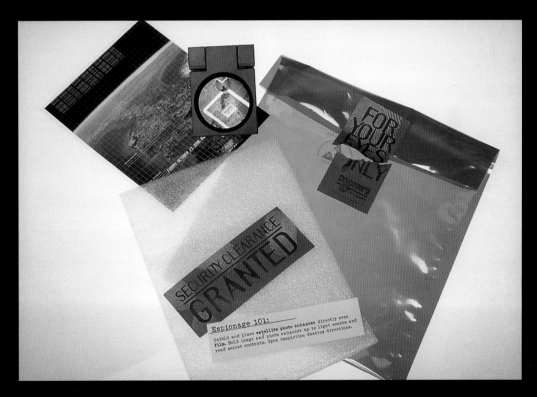

Each year, Discovery Networks Latin America pulls out all the stops and puts on the biggest party of the year. And each year they count on us to get people there.

All of the invitations we design tie into Discovery's programming. One year, dog tags and canteens connected the party to their adventure programming. One year, antique maps and compasses highlighted their exploration shows.

This invitation is for an espionage-themed blowout to promote Discovery's SpyTek show starring former James Bond actor Roger Moore. Several hundred invitees received a pop-up magnifying glass and a negative transparency of a satellite shot of Florida with the party location positioned under crosshairs along with the suggestion to hold the date open. Then, a few weeks later, the audience received a strip of developed 35-mm film with all of the party particulars spelled out.

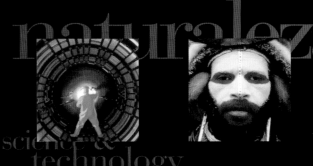

EXPLORE YOUR WORLD™

Discovery CHANNEL

LATIN AMERICA/IBERIA

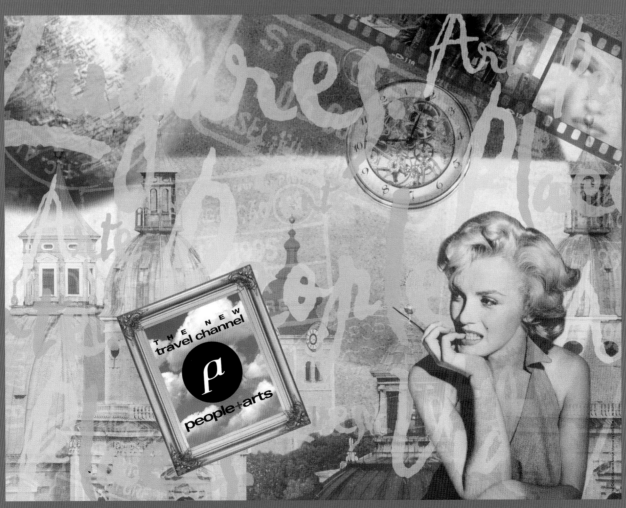

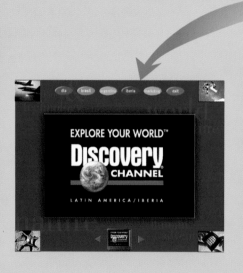

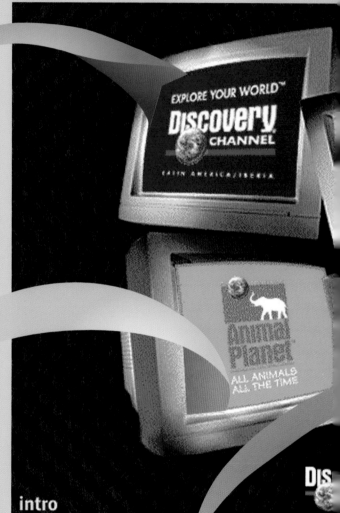

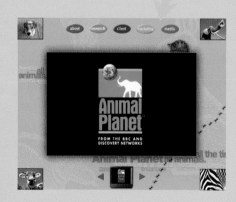

Thanks to incredible programming and phenomenal growth, Discovery Networks expanded its initial offering to four; the original Discovery Channel, Discovery Kids, People + Arts, and Animal Planet. To sell all of these great signals, we created an interactive presentation that Discovery's salesforce could carry around in their laptops. The beautiful thing about the

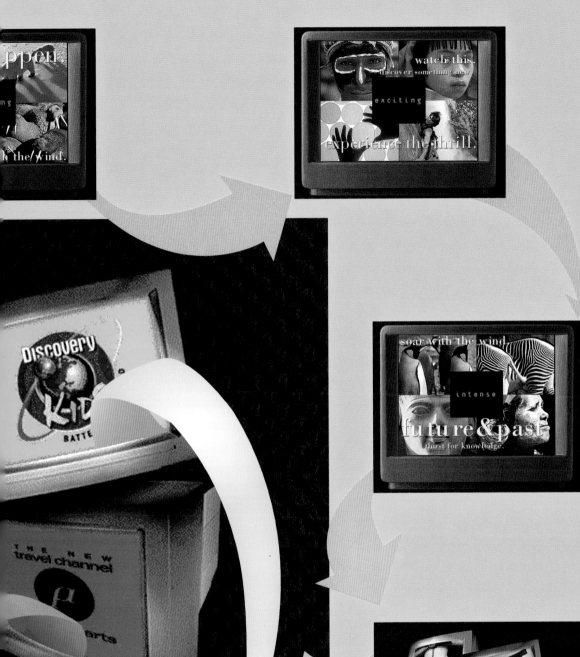

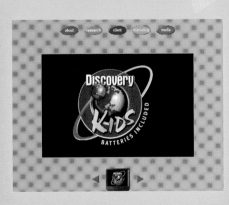

presentation is that it's not linear. Unlike slide shows or flip charts, which force the salesperson to make exactly the same presentation every time, a non-linear show can be built on the fly, responding to the audiences' wants and needs. Also, no matter how many facts, photos, videos, and languages we include, the laptop doesn't get any heavier.

Designing Eye designs and manufactures cutting-edge furniture for well-known (and well-heeled) customers such as Gianni Versace and Sylvester Stallone. Unfortunately, we couldn't use these celebrity names. But we could explain Designing Eye's unique, over-the-top, royalty-on-acid opulence with headlines such as "It's like Queen Isabela meets Timothy Leary."

Flamenco with
a heavy metal twist.

Designing Eye

Conquistador
meets dominatrix.

Designing Eye

Catalán
for couch potatoes.

Designing Eye

E-Serve. An electronic travel agency concept owned by Alamo Rent-A-Car.

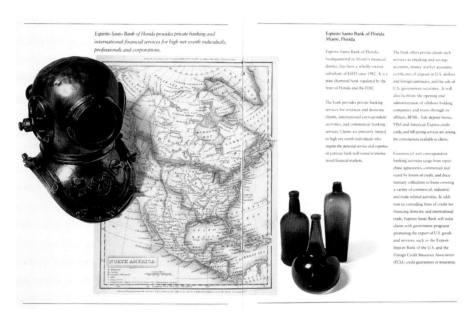

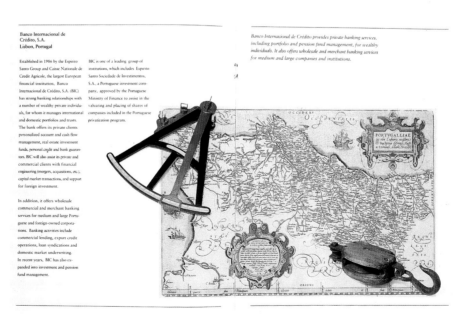

The Espirito Santo family has owned this Portugal-based bank for centuries. We chose to highlight the bank's antiquity and maritime heritage by featuring fascinating maps and heirlooms from their history.

GUESS WHICH ONE COSTS MORE.

Guess again. Because chances are the photocopier will burn a hole in your pocket faster than the car. Especially when you factor in expenditures for ongoing lease/maintenance agreements, depreciation, downtime, insurance, supplies ... well, you get the picture. And it isn't pretty.

Fact is, each piece of your firm's automated office equipment – from phone systems to fax machines, word processors to postage meters – comes with its own array of hidden expenses. Which, over time, can add up to hundreds of thousands of dollars in unrecovered costs.

But before you trade it all in for something cheaper – like, say, a villa in the South of France – we propose a far more practical solution: an Equitrac Automated Cost Recovery System.

Equitrac's easy-to-use control terminals, linked to a central processing unit, will automatically – and accurately – track each piece of equipment's activity by user, client, and matter. And then post itemized charges directly to your existing billing software.

In short, by keeping tabs on the machine on the right, Equitrac will keep your firm running as smoothly as the one on the left. To find out more, send in the coupon below. Or call us at **800-327-0183**.

68

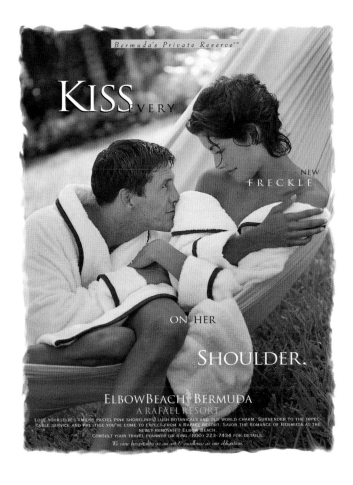

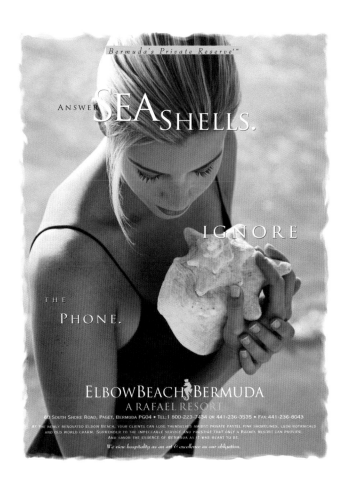

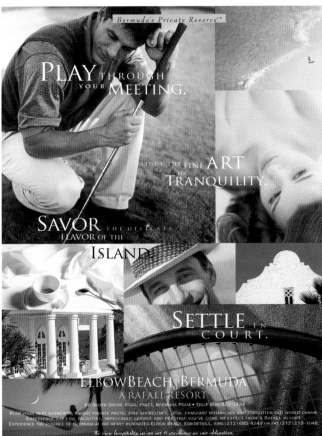

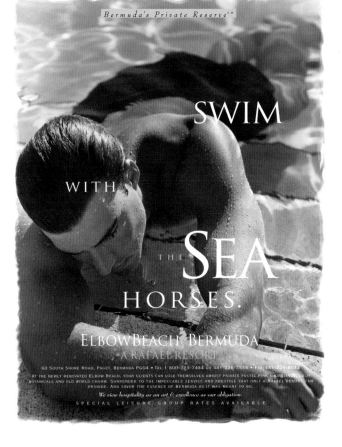

Sure, this prestigious resort boasted extravagant amenities, a staff obsessed with pleasing their guests, and a lengthy European heritage. But we left it to our competitors to focus on resort features. We cut to the quick and got down to the real reason people choose to vacation in a hotel of Elbow Beach's personality, location and stature. To escape — Completely and utterly. And our ads communicated that fact. Completely and utterly.

Our assignment was to attract American companies and investors to El Salvador. Although the business leaders in the small, Central American country insisted that their country's attributes were enough to entice business, our research proved otherwise. What we did find out was that the North American professionals we interviewed were most intrigued by the companies that were already doing business in the country; Ocean Pacific, Frederick's of Hollywood, McDonald's, Sears, and other leading American firms. Our strategy statement: "Guess who's doing business in El Salvador" grew right out of our focus groups.

FUTURE

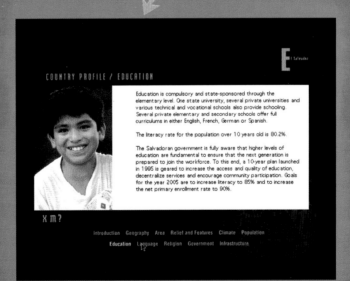

COUNTRY PROFILE / EDUCATION

Education is compulsory and state-sponsored through the elementary level. One state university, several private universities and various technical and vocational schools also provide schooling. Several private elementary and secondary schools offer full curriculums in either English, French, German or Spanish.

The literacy rate for the population over 10 years old is 80.2%.

The Salvadoran government is fully aware that higher levels of education are fundamental to ensure that the next generation is prepared to join the workforce. To this end, a 10-year plan launched in 1995 is geared to increase the access and quality of education, decentralize services and encourage community participation. Goals for the year 2005 are to increase literacy to 85% and to increase the net primary enrollment rate to 90%.

Introduction Geography Area Relief and Features Climate Population

Education Language Religion Government Infrastructure

FUTURE

INVESTMENTS

Click here to skip introduction...

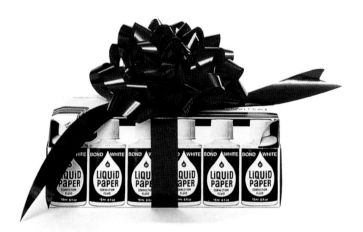

Inside:
Five Somewhat More Colorful Gift Ideas
For Secretary's Week.

Secretaries get lots of pens and bottles of White-Out. They want something nicer — especially on Secretaries' Day.

You are
cordially invited to
apologize to the
rainforest.

Fairchild Tropical Garden Conservatory Opening
10901 Old Cutler Road Miami, Florida

We figured out how
to preserve the rainforest.
We're placing it
in captivity.

Fairchild Tropical Garden Conservatory Opening
10901 Old Cutler Road Miami, Florida

Come see
the rainforest in
.0000001%
of its majesty.

Fairchild Tropical Garden Conservatory Opening
10901 Old Cutler Road Miami, Florida

We're placing what's
left of the rainforest
in a glass house.
Quite frankly, you've
left us no choice.

Fairchild Tropical Garden Conservatory Opening
10901 Old Cutler Road Miami, Florida

Fairchild Tropical Gardens, one of the leading botanical gardens in the world, created a conservatory program promoting rain-forest preservation. When they asked us to publicize their exhibit, they asked for two things — that we increase attendance to the garden and that we increase local awareness of the problem of rapid deforestation. Our retailer's sense-of-urgency strategy met both of these requirements — and even let people chuckle about a situation that is anything but funny.

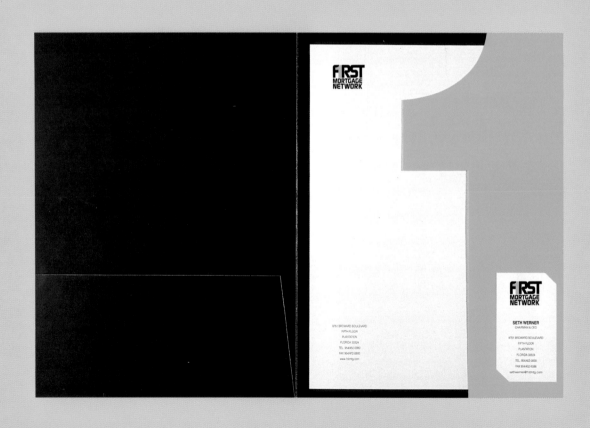

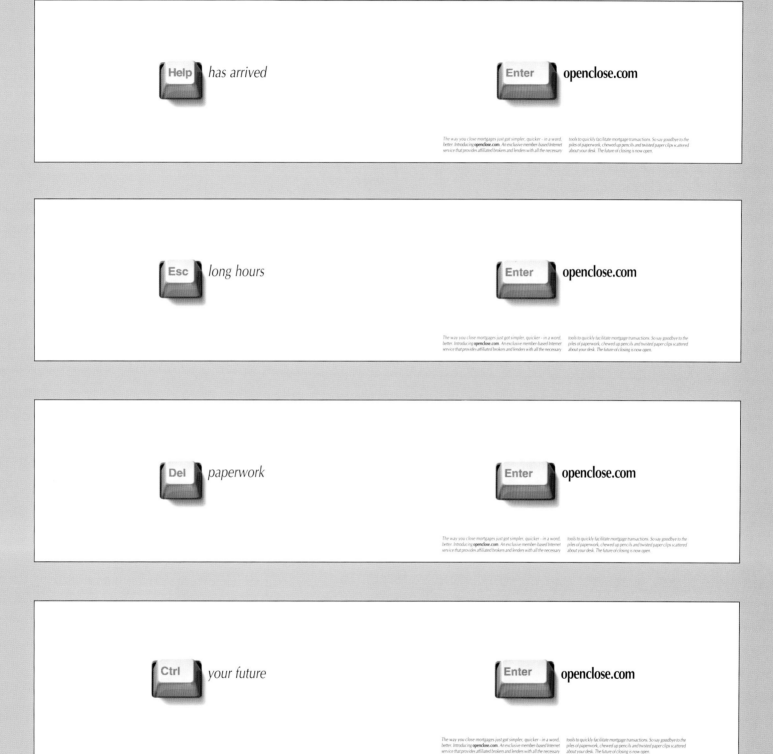

If your client is revolutionizing the mortgage industry, you'd damn well better have a good way of letting people know about it. We did. These ads utilize the simplicity of a computer key to help deliver the message that First Mortgage Network's newly created Internet site provides brokers and lenders with all the necessary tools to make mortgage transactions simpler and faster.

EXCUSE OUR DECOR

(All we care about is giving you great suits at low prices)

FAMOUS GARMENT
SMART SUITS. LOW PRICES. (MEDIOCRE ADVERTISING)

SORRY, NO ESPRESSO BAR

(All we care about is giving you great suits at low prices)

FAMOUS GARMENT
SMART SUITS. LOW PRICES. (MEDIOCRE ADVERTISING)

NO
WE DON'T PLAN ON RE-DECORATING

(All we care about is giving you great suits at low prices)

FAMOUS GARMENT
SMART SUITS. LOW PRICES. (MEDIOCRE ADVERTISING)

WE DON'T ALLOW ANY FRILLS IN HERE.
EXCEPT ON THE CLOTHES.

(All we care about is giving you great suits at low prices)

FAMOUS GARMENT
SMART SUITS. LOW PRICES. (MEDIOCRE ADVERTISING)

If we had used Claudia, Cindy or Naomi in this ad, our suits would cost twice as much.

We prefer our model. She's just as pretty and is a lot cheaper.

Besides, all we want to do is offer you TOP QUALITY WOMEN'S SUITs at the LOWEST PRICES available. (Isn't that what you'd rather have, anyway?) Visit our warehouse and you'll find the same great suits you've seen in major department stores— for nearly HALF THE COST— all the time. Our prices start at $49. and they don't go much higher.

So come to Famous Garment, at 1060 East 23rd Street, Hialeah. Our hours are Thursday, 10-6; Friday and Saturday, 10-5; and Sunday, 12-5. For more information, call 696-3971. All you want are GREAT DEALS— and that's all we're offering.

FAMOUS GARMENT
SMAR SUITS. LOW PRICES.
(MEDIOCRE ADVERTISING)

It's our brand new line. It's our same old ad.

To announce our new spring line, we wanted our ad agency to create a magnificent new advertising campaign. Until they told us what it would cost.

If we spent all our money on great ads, we couldn't offer you low, low prices like these: *Buy 2 SPRING SUITS starting at just $99. They're the same new designer fashions you'll see in the big department stores—for 1/3 THE PRICE.

So visit Famous Garment, at 1060 East 23rd Street, (3 blocks east of LeJeune Road), Hialeah. We're open Wed, 10-5; Thurs, 10-8; Fri and Sat, 10-5; and Sun, 12-5. For details, call 696-3971. Our ads may be boring but our low prices sure are refreshing.

FAMOUS GARMENT
SMART SUITS. LOW PRICES.
(MEDIOCRE ADVERTISING)

Our ladies' suits are selling so fast we couldn't even spare one for this ad.

Deepest apologies to our model. But that's what happens when offering such a terrific deal: all TOP QUALITY LADIES' SUITS, 3 for $99. They're the same great suits you've seen in major department stores—at less than 1/2 PRICE. Check them out now. We're open seven days a week. Famous Garment, 1060 East 23rd Street, Hialeah. For details, call 696-3971. Visit soon. Before our racks are bare.

FAMOUS GARMENT
SMART SUITS. LOW PRICES.
(MEDIOCRE ADVERTISING)

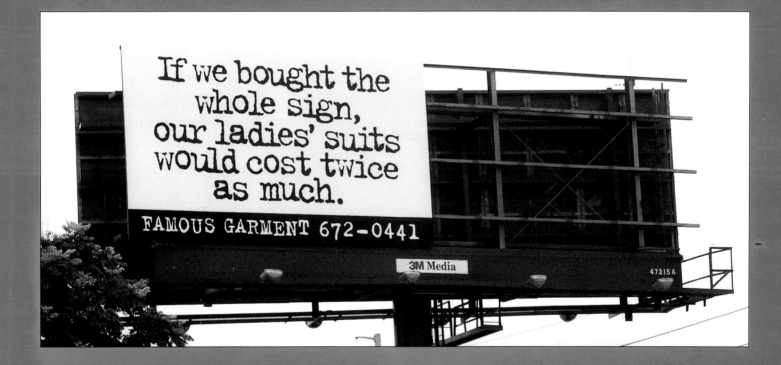

Famous Garment was a chain of factory-direct retail stores, most of which were located in mean little warehouses in truly horrible industrial neighborhoods. Their one real asset was that they really did sell top-notch clothes at rock-bottom prices.

Our brain dart, "Smart Suits. Low Prices. Mediocre Advertising," promised our patrons that we didn't spend money on anything but the merchandise so we could give them the lowest possible prices. And our illustrations, drawn by copywriter David Evans, proved it.

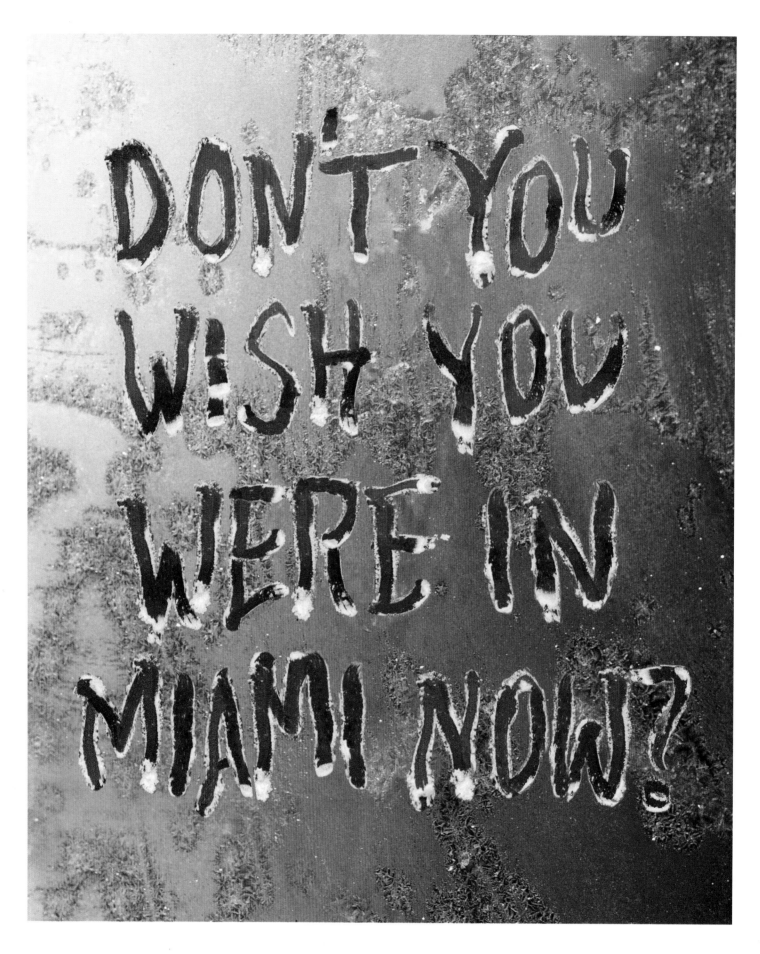

Typically, travel-agent displays feature a destination shot. We took a radically different approach and designed an electrostatic (the static-cling plastic they make sunglass labels with) window poster with the words, "Don't you wish you were in Miami now?" written through icy frost.

Travel agents loved the posters and couldn't get enough of them — in fact, the Greater Miami Convention & Visitors Bureau's inventory was immediately depleted by the overwhelming number of requests for extra posters. And based on room bookings, northerners couldn't get enough of Miami, either.

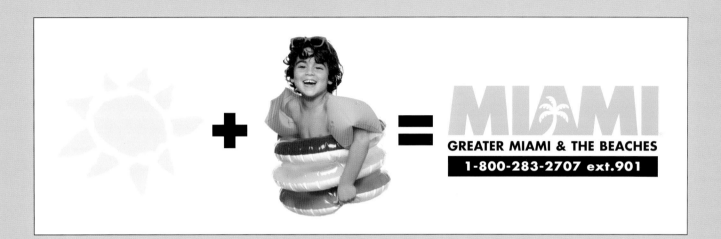

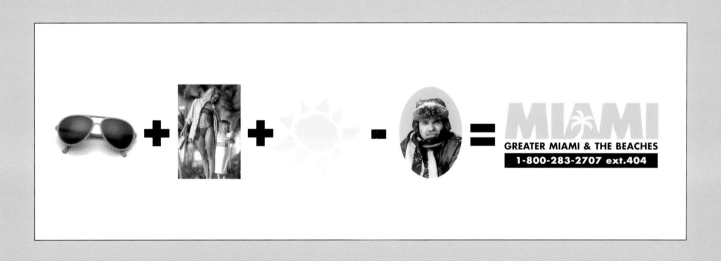

We wanted to point out that there's a lot for international vacationers to do in Miami. So we showed them. Our ads used visual elements instead of words to communicate the essential characteristics of Miami — exciting, enjoyable, progressive, warm, friendly. The campaign is fun to look at and it gets a strong message across quickly in a category overrun with look-alike advertising. And you don't even need to understand English to understand our ads.

FWD

SCAN

ING 15297

These ads ran on the weather page of the *New York Times*, right below the weather map. That way, when people checked their paper to see if they needed to put on their galoshes and snow tires, we could playfully show them ways to stay warm and suggest that they would do better by coming down to Miami.

82

1. SFX: Pool-side sounds.
 AUDIO: Sexy sax music throughout.

2.

3.

4. V/O: (very sensual, breathy female)
 "Down here . . ."

84

5. ". . . we usually throw on a coat . . ."

6. ". . . in the winter, too."

7.

8.

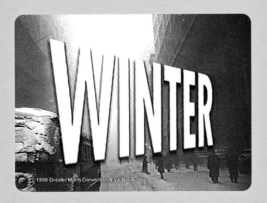

1. AUDIO: (Campy music throughout) Winter. A time of snow, cold…

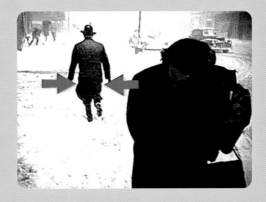

2. AUDIO: …and frozen tuchases.

3. AUDIO: Instead of enduring hostile Arctic discomfort, find a nearby chestnut cart and cuddle up to it.

4. AUDIO: (Switch to salsa music) You can obtain heat more directly by coming to Greater Miami & the Beaches. Here, we'll teach you…

5. AUDIO: …Which boutiques to shop.

6. AUDIO: Which new trendy bistros to explore.

7. AUDIO: And how to really get down and boogie.

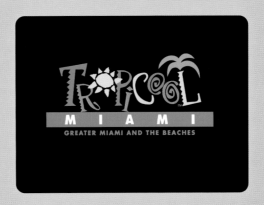

8. AUDIO: Miami. It's Tropicool!

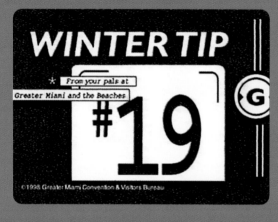

1. AUDIO: (Campy music throughout)

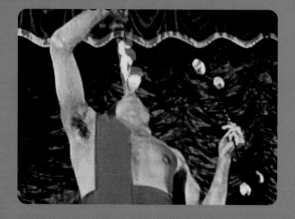

2. AUDIO: Take up fire-eating.

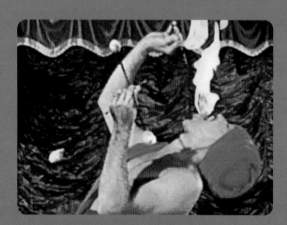

3.

4. AUDIO: (Switch to salsa music)
Or visit Miami and feel hot all over.

Miami. It's Tropicool!

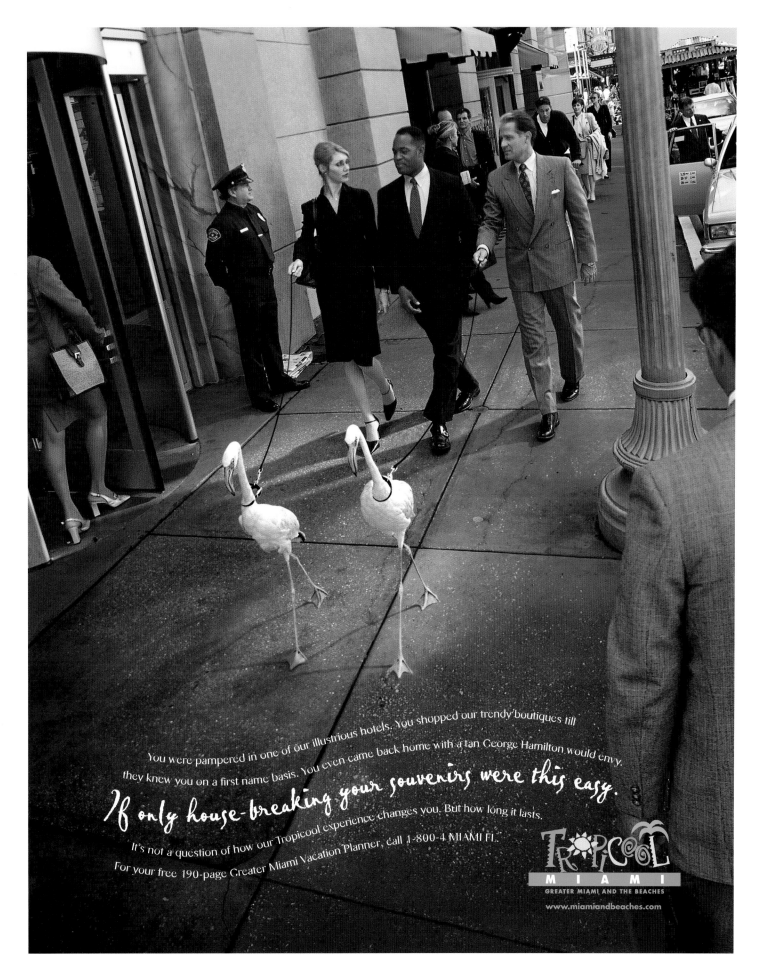

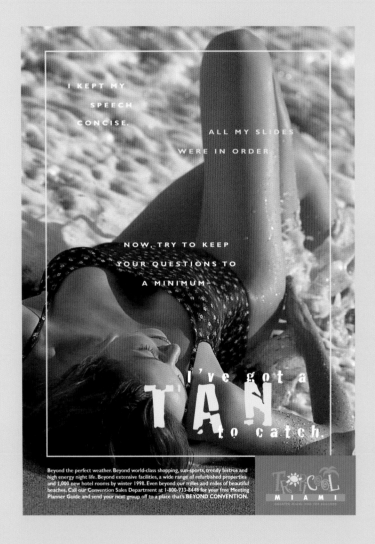

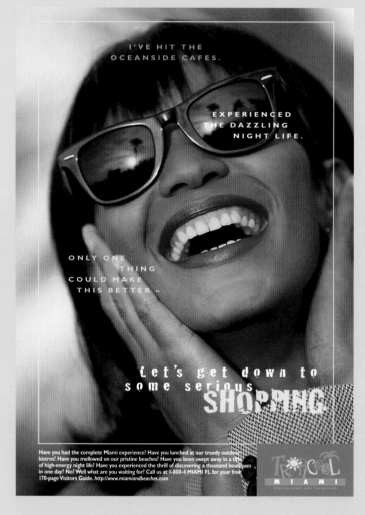

THE AMENITIES ARE
BEYOND IMAGINATION.

THE ACCOMMODATIONS
ARE BEYOND EXPECTATION.

EVERYTHING ABOUT THIS PLACE
IS BEYOND CONVENTION.

AND
SO ARE THE
Piña
coladas.

Beyond the perfect weather. Beyond the world-class shopping, sun-sports, trendy
bistros and high-energy night life. Beyond extensive facilities, a wide range of refur-
bished properties, and 1,000 new hotel rooms by 1999. Even beyond our miles and
miles of beautiful beaches. Call our Convention Sales Department at 1-800-933-8448
or e-mail services@miamiandbeaches.com for your free Meeting Planner Guide
and send your next group off to a place that's BEYOND CONVENTION.
http://www.miamiandbeaches.com

TropiCool
MIAMI
GREATER MIAMI AND THE BEACHES

Fish sticks should be frozen.
Not people.

1-800-4 MIAMI FL

Hey, nice ear muffs.

1-800-4 MIAMI FL

If heat rises, why is it so
%@##@%@#!! cold up here?

1-800-4 MIAMI FL

Come here a wound-up, type-A suit.

Leave a tanned wound-up, type-A suit.

MIAMI DADE 2000 DEMOCRATIC NATIONAL CONVENTION

Haverfield
Corporation

Hammock's
Veterinary Clinic

Greater Miami
Hotel Association

Speaking as NCL's exclusive rent-a-car partner,
Hertz has a couple words of encouragement for you:

For those of you not up on your signal flags, that means "Keep Cruising" in naval-speak.

And it's something Hertz can really help you to accomplish. Because when you return from your high seas adventure, we'll be right there at the port. Ready to set you up with a highway cruise guaranteed to add its own kind of adventure to your vacation.

You can take in the local sights. Stretch out your sea legs. And work off some of those accumulated calories before heading bravely back to workaday life.

Our low unlimited-mileage weekly and weekend rates make it all very affordable. And our service will make you feel like you're still on the ship.

So next time you cruise with NCL, have your Travel Agent arrange a little Hertz cruise extender. Or call us yourself at 1-800-654-3131.

It'll help take the sting out of coming home.

mIa

Demographers say that today's Miami resembles what the rest of the country will look like in the next twenty to thirty years — a dynamic community made up of almost 93 percent of the world's peoples and cultures. It is this diversity, in fact, that has helped to create Miami's uniqueness and unifying strength. Our challenge was to figure out a way to tell this

ami

to the local community. And, of course, we wanted to do it in a way that was powerful, arresting, and compelling — in short, we wanted to create a brain dart. What we discovered was that our own name, MIAMI, contained everything we needed to communicate. And so I Am Miami was born to let our people know that each of them was integral to our unique power.

1.

2.

3.

4. AUDIO: A breast self-exam is almost as easy as getting undressed.

**Breast Health Center
Jackson Memorial Hospital**

585–7637

5. For a free guide, please call.

THINK BACK TO LAST NIGHT'S NEWS:

WHERE'D THEY TAKE THE GUY IN THE CAR CRASH?
THE WOMAN IN THE BOATING ACCIDENT?
THE KID WHO GOT SHOT?

**University Of Miami
Jackson Memorial
Medical Center**

WORLD CLASS HEALTH CARE. HERE IN SOUTH FLORIDA.

Research showed that when people were asked where the best trauma care in South Florida was, every one of them chose Jackson Memorial Medical Center. With that input, we thought it better to let the reader's subconscious provide the answer than for the ad to shove it down their throats. After all, brain darts don't have to hurt.

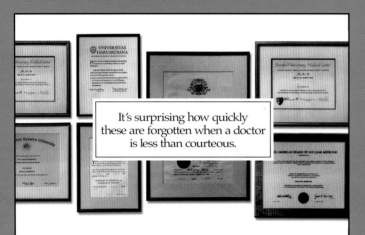

*Each season,
thousands of people
are committed to
an institution.*

Joe's
Stone Crab Restaurant
SINCE 1913 (305)673-0365 TAKE AWAY(305)673-4611

*Not new.
Not improved.*

Joe's
Stone Crab Restaurant
SINCE 1913 (305)673-0365 TAKE AWAY(305)673-4611

*Our stone crab
claws don't cost an
arm & a leg.*

[UNLESS, OF COURSE, YOU'RE A STONE CRAB.]

Joe's
Stone Crab Restaurant
SINCE 1913 (305)673-0365 TAKE AWAY(305)673-4611

*Feed your
client's ego.*

Joe's
Stone Crab Restaurant
SINCE 1913 (305)673-0365 TAKE AWAY(305)673-4611

Worth the schlep.

Joe's
Stone Crab Restaurant
SINCE 1913 (305)673-0365 TAKE AWAY(305)673-4611

*Before SoBe,
Joe be.*

Joe's
Stone Crab Restaurant
SINCE 1913 (305)673-0365 TAKE AWAY(305)673-4611

Calling all procrastinators.

[CLOSING FOR THE SEASON ON MAY 15TH]

Joe's
Stone Crab Restaurant
SINCE 1913 (305)673-0365 TAKE AWAY(305)673-4611

Feast before famine.

[LAST SERVING DAY – MAY 15TH]

Joe's
Stone Crab Restaurant
SINCE 1913 (305)673-0365 TAKE AWAY(305)673-4611

Better get crackin'

[CLOSING FOR THE SEASON ON MAY 15TH]

Joe's
Stone Crab Restaurant
SINCE 1913 (305)673-0365 TAKE AWAY(305)673-4611

Starting tomorrow, there'll be an extra long wait for a table.

[TODAY'S OUR FINAL SERVING DAY –
RETURNING OCTOBER 15TH]

Joe's
Stone Crab Restaurant
SINCE 1913 (305)673-0365 TAKE AWAY(305)673-4611

Apresúrese a darse un gusto para evitar un disgusto.

[ULTIMO DIA DE SERVICIO 15 DE MAYO –
REGRESAMOS 15 DE OCTUBRE]

Joe's
Stone Crab Restaurant
SINCE 1913 (305)673-0365 TAKE AWAY(305)673-4611

A partir de mañana tendrá que esperar mucho tiempo por una mesa.

[HOY ES EL ULTIMO DIA DE SERVICIO –
REGRESAMOS 15 DE OCTUBRE]

Joe's
Stone Crab Restaurant
SINCE 1913 (305)673-0365 TAKE AWAY(305)673-4611

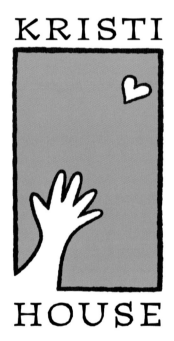

KRISTI

HOUSE

Kristi House is a wonderful organization that serves as an advocate for children who have been sexually abused. Besides providing counseling and referrals, Kristi House acts as a liaison between the various parties involved in such tragedies: medical professionals, law-enforcement personnel, long-term therapists, and parents. Our job was to offer hope while we made sure people didn't turn the page. Or turn their backs on Kristi's kids.

ITALIAN DRESSING
60% OFF.

We've got tasty clothes from the U.S. of A. too,
and they're all on sale. Which means that starting Thursday
you can look like a million bucks for a whole lot less.

LANES

The finest men's clothes at the corner of Red & Sunset.

SURE OFF-THE-RACK SUITS FIT GREAT. IF YOU'RE A RACK.

This week only, all of our made-to-measure suits are priced the same as our ready-to-wear. At Lanes our tailor is so good even our price tags are more comfortable.

LANES

The finest men's clothes at the corner of Red & Sunset.

CUSTOM. FOR THE PRICE OF COMMON.

At Lanes we proudly offer made-to-measure suits from Ermenegildo Zegna, Italy's master craftsman. And for a limited time, your made-to-measure Zegna suit will cost the same as an off-the-racker.

LANES

The finest men's clothes at the corner of Red & Sunset.

IF YOUR HICKEY-FREEMAN SUIT FITS LIKE IT WAS MADE JUST FOR YOU, IT'S BECAUSE IT WAS MADE JUST FOR YOU.

Here's a unique opportunity to enjoy a custom fit and an extraordinary value from America's most distinguished maker of business suits. Hickey-Freeman Made-to-Measure suits for the price of Ready-to-Wear.

LANES

The finest men's clothes at the corner of Red & Sunset.

IN A COUNTRY KNOWN FOR CUSTOM FERRARIS AND MADE-TO-ORDER LAMBORGHINIS, WHY WOULD YOU SETTLE FOR AN OFF-THE-RACK SUIT?

Italy is known for three things: fast cars, great food and beautiful clothes. And while we'd probably recommend that you go to Italy for the first two, we suggest that you visit us for the third. Because our sale may be your only chance to drive a Ferrari at Firebird prices.

LANES

The finest men's clothes at the corner of Red & Sunset.

In general, South American airlines have flighty reputations. Most are regional carriers with few connections and even fewer praiseworthy attributes. Because LanChile is the exception, we could focus on the facts: a modern fleet, top-notch service, superior in-flight dining, and 27 well-connected destinations. And we did it in a mind-catching way, on a tight budget, and within even tighter time frames.

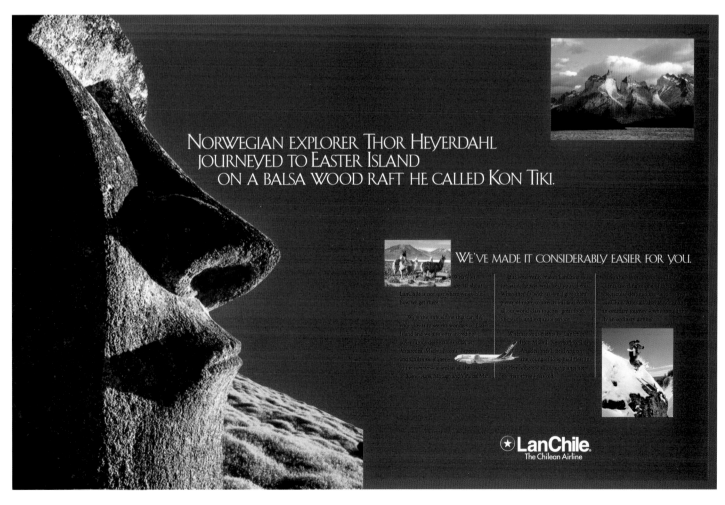

110

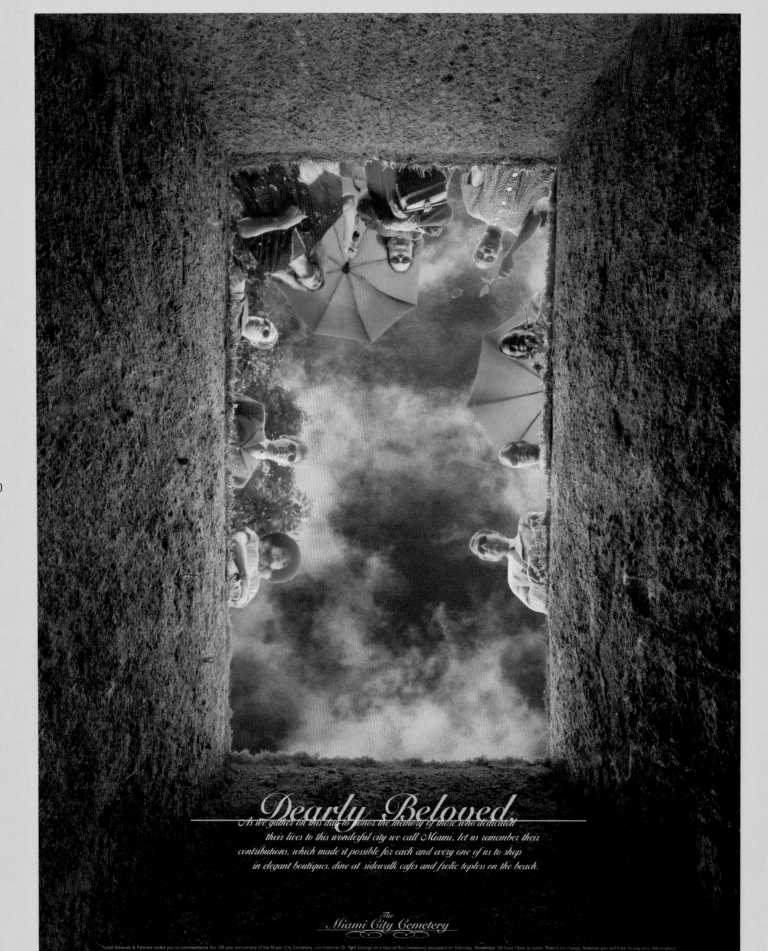

Dearly Beloved.

As we gather on this day to honor the memory of those who dedicated
their lives to this wonderful city we call Miami, let us remember their
contributions, which made it possible for each and every one of us to shop
in elegant boutiques, dine at sidewalk cafes and frolic topless on the beach.

The
Miami City Cemetery

Turkel Schwartz & Partners invites you to commemorate the 100 year anniversary of the Miami City Cemetery. Join historian Dr. Paul George on a tour of this fascinating graveyard on Saturday, November 18 from 10am to noon. There's no charge, however you will have to pay your last respects.

On the morning after Halloween, we hosted a private guided tour to celebrate the 100th anniversary of Miami's oldest cemetery .
When we created the poster, we avoided talking about how people were dying to get in and instead took a shot from six feet under.

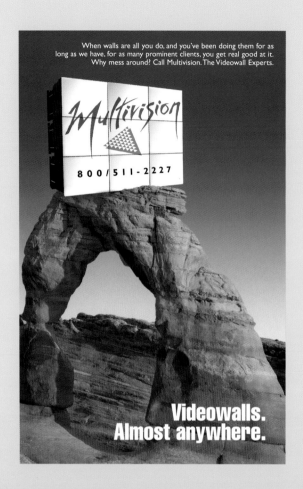

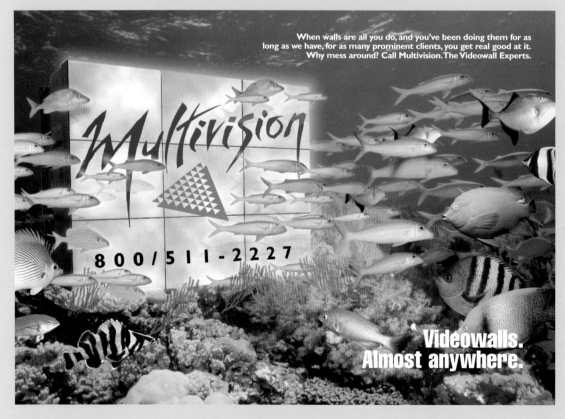

Before Billy the Marlin. Before the surprise '97 World Series title. Before the sackings, tradings, and disgruntlements.

Back in the '80s, AAA-league ball came to town for about 37 minutes. And we were ready with a fitting logo.

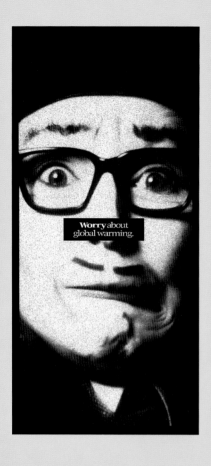

Worry about
global warming.

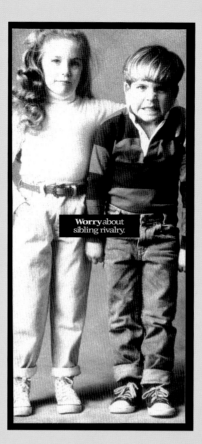

Worry about
sibling rivalry.

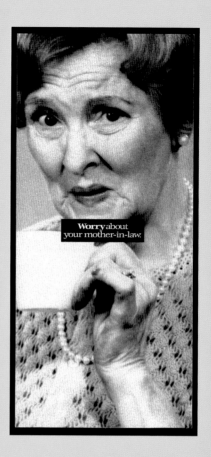

Worry about
your mother-in-law.

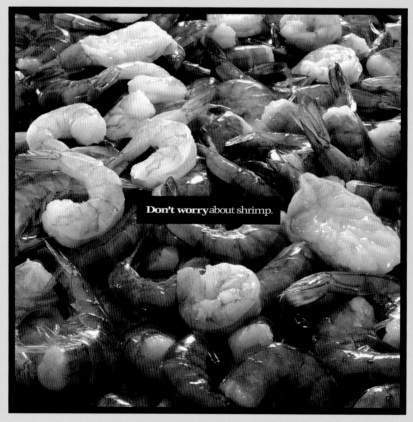

Don't worry about shrimp.

Midland, a shrimp importer from El Salvador had come up with a new quality-control system that assured their customers of perfect product every time. We chose not to tell our audience how wonderful the new system was.

Instead, we positioned our tongues firmly in our cheeks and pointed out all the things our readers could now spend their time worrying about since they no longer had to worry about shrimp.

117

During just the first few years of its existence, the Miami Film Festival was lucky enough to host the U.S. and world premieres of some very visible flicks. Enough to write a story about. So we did.

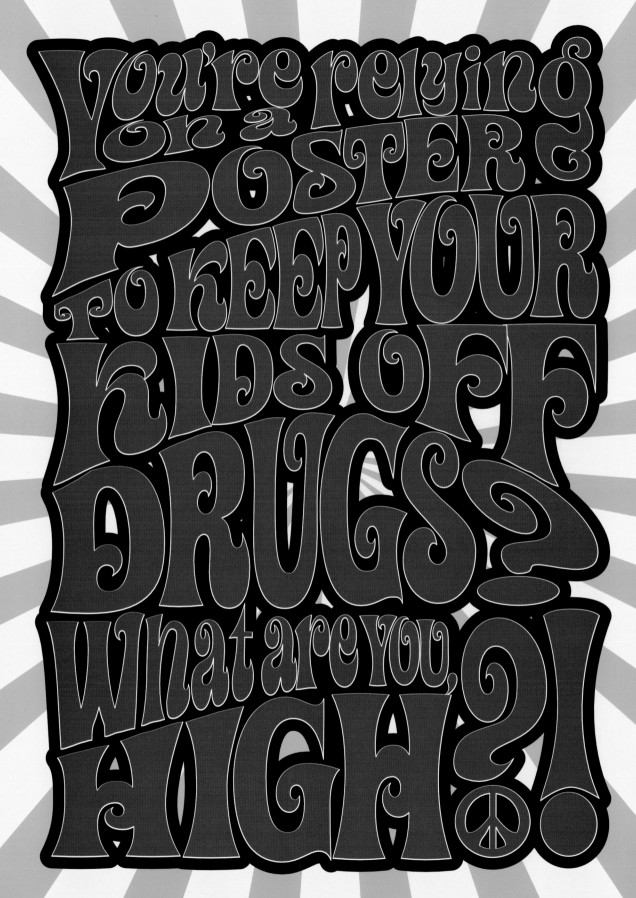

Every anti-drug advertisement has a voice. But it's not your voice. The best way to get the message across to your kids is for you to deliver it. Period.
For more on how we can help you help them, call The Miami Coalition at 305-375-8032.

Studies show that 40-something parents are unlikely to talk to their children about illicit drug use because they're embarrassed to discuss their own experimentation. The same studies show that kids would be much less likely to use drugs if their parents talked to them about it. Our job was to align perceptions with reality and remind parents just how important their role is.

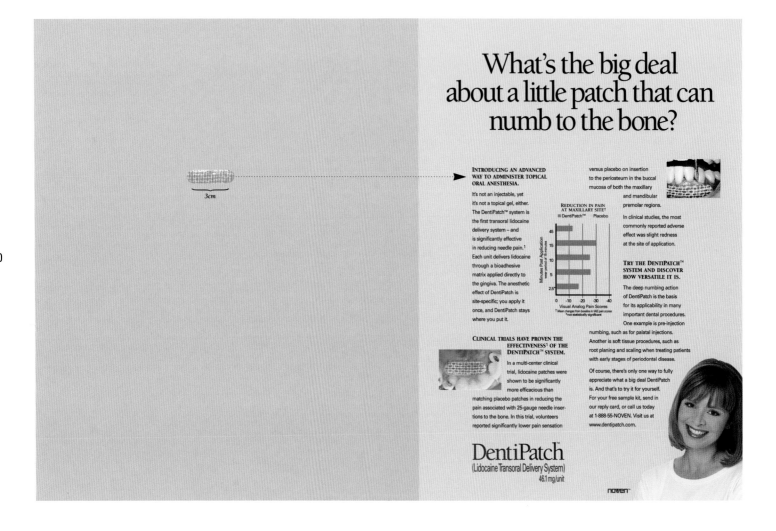
120

Fear of pain is the top reason people don't visit their dentists more often. Noven had developed an incredibly effective method of pain management that could reduce pain and pain-related anxiety — but we couldn't say that. In fact, according to the FDA, there was very little we could say.

We asked the dental community a question: "What's the big deal about a little patch that can numb to the bone?" We then went on to support the implied claim with every bit of clinical evidence at our command. All without mentioning comfort, fear, or increased patient satisfaction once in any of our materials.

Introducing an advanced
way to administer lidocaine.

DentiPatch
(Lidocaine Transoral Delivery System)
46.1 mg/unit

Application Video

DentiPatch
(Lidocaine Transoral Delivery System)
46.1 mg/unit

YOU DON'T HAVE TO CARE FOR ALL YOUR TEETH.

JUST THE ONES YOU WANT TO KEEP.

Employees are a lot like teeth. You need to take care of the ones you want to keep. With OHS dental plans, you'll be able to offer the attractive benefits package high-caliber employees expect. Complex procedures at a fraction of the cost and complete preventive and diagnostic care at no charge to them. For more information, call OHS at 1-800-223-6447. We'll show you how to keep your teeth and your employees.

OHS ORAL HEALTH SERVICES OF FLORIDA

GROWING UP
HEALTHY

This logo was designed for a wonderful organization that creates and maintains medical records for low-income children who may otherwise not have this basic need taken care of.

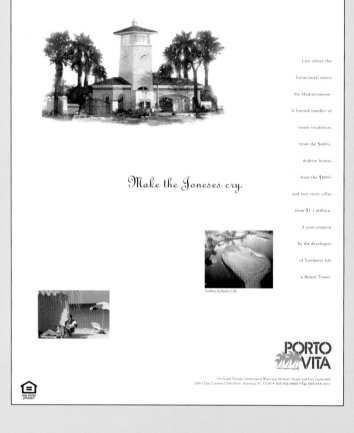

Make the Joneses cry.

Live where the

Intracoastal meets

the Mediterranean

A limited number of

tower residences

from the $400's,

midrise homes

from the $800's

and two-story villas

from $1.1 million.

A joint creation

by the developers

of Turnberry Isle

& Bristol Tower

Turnberry Isle Resort & Club

Sorry, you won't have
the only Van Gogh
on the block.

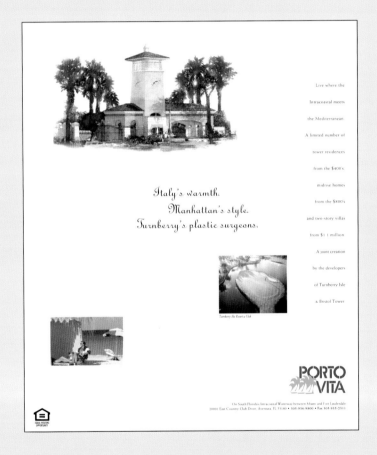

How do you introduce a new ultra-luxury residential development without resorting to old rhetoric such as "exclusive" and "private enclave"? We did it by speaking to buyers as real people.

Real people who just happened to have a million or so dollars to spend on a residence.

Most hotel restaurants deserve their bad rap — they are often overpriced and under-inspired. Dux and Capriccio, on the other hand, are two restaurants that would thrive anywhere — yet there they are in the lobby of the Peabody Orlando.

Ad 1 (top left):

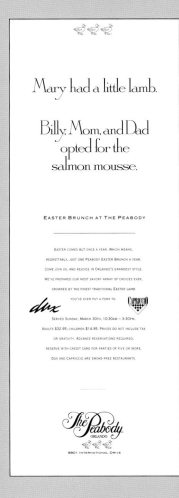

Mary had a little lamb.

Billy, Mom, and Dad opted for the salmon mousse.

EASTER BRUNCH AT THE PEABODY

Easter comes but once a year. Which means, regrettably, just one Peabody Easter Brunch a year. Come join us, and rejoice in Orlando's grandest style. We've prepared our most savory array of choices ever, crowned by the finest traditional Easter lamb you've ever put a fork to.

dux CAPRICCIO

Served Sunday, March 30th, 10:30am – 3:30pm. Adults $32.95; children $14.95. Prices do not include tax or gratuity. Advance reservations required. Reserve with credit card for parties of five or more. Dux and Capriccio are smoke-free restaurants.

The Peabody
ORLANDO
9801 INTERNATIONAL DRIVE

Ad 2 (top center):

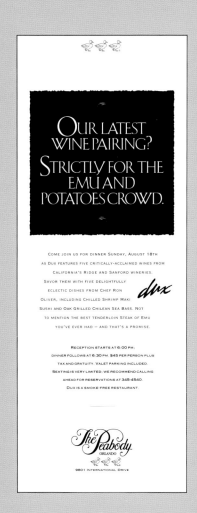

OUR LATEST WINE PAIRING? STRICTLY FOR THE EMU AND POTATOES CROWD.

Come join us for dinner Sunday, August 18th as Dux features five critically-acclaimed wines from California's Ridge and Sanford wineries. Savor them with five delightfully eclectic dishes from Chef Ron Oliver, including Chilled Shrimp Maki Sushi and Oak Grilled Chilean Sea Bass. Not to mention the best Tenderloin Steak of Emu you've ever had — and that's a promise.

dux

Reception starts at 6:00 pm. Dinner follows at 6:30 pm. $45 per person plus tax and gratuity. Valet parking included. Seating is very limited; we recommend calling ahead for reservations at 345-4540. Dux is a smoke-free restaurant.

The Peabody
ORLANDO
9801 INTERNATIONAL DRIVE

Ad 3 (top right):

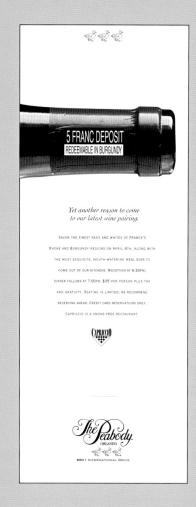

5 FRANC DEPOSIT
REDEEMABLE IN BURGUNDY

Yet another reason to come to our latest wine pairing.

Savor the finest reds and whites of France's Rhone and Burgundy regions on April 4th, along with the most exquisite, mouth-watering meal ever to come out of our kitchens. Reception at 6:30pm; dinner follows at 7:00pm. $35 per person plus tax and gratuity. Seating is limited; we recommend reserving ahead. Credit card reservations only. Capriccio is a smoke-free restaurant.

CAPRICCIO

The Peabody
ORLANDO
9801 INTERNATIONAL DRIVE

Ad 4 (bottom left):

TEST YOUR CULINARY LITERACY
(#58 IN A SERIES)

BUCATINI CON POLLO IS:

a) The mysterious Fourth Tenor
b) Miss Bucatini before the operation.
c) One of the delectable entrées on Capriccio's 10th Anniversary menu

The answer is obvious – and delicious. Especially when enjoyed with a complimentary bottle of our Tenth Anniversary Wine. It's all part of our commemorative $49.95 dinner for two – celebrating ten years of fine service and even finer meals.

CAPRICCIO

Dinner at Capriccio. Proof that Italy's greatest works of art are created in the kitchen. Served Tues thru Sun 6 - 11 pm.

The Peabody
ORLANDO
9801 INTERNATIONAL DRIVE

Ad 5 (bottom center):

HOW to END it ALL.

This New Year's Eve, Choose Between Two Delightful Options.

Conclude 1997 in elegance and style with what can only be described as the meal to end all meals. Featured offerings: Beluga & Quail Egg hors d'oeuvres followed by Colorado Lamb Chops and Large Shrimp with Lavish Asian Marinades, Crispy Leek Threads, and Sauté of Fancy Mushrooms. Served 6 – 11pm. $75 per adult; $45 per child 6 to 12. Does not include tax and gratuity. Children 5 and under free with purchase of adult entrée.

dux

Or, celebrate the year's end the Italian way, featuring a tantalizing spread that includes your choice of Osso Bucco Milanese, Salmone alla Griglia or Scaloppine d Vitello. Served 6 – 11pm. $38 per adult; $11.95 per child 6 to 12. Does not include tax and gratuity. Children 5 and under free with purchase of adult entrée.

CAPRICCIO

The Peabody
ORLANDO
9801 INTERNATIONAL DRIVE

Ad 6 (bottom right):

TEST YOUR CULINARY LITERACY
(#11 IN A SERIES)

GRILLED CAROLINA SQUAB IS:

a) What you get when one lands on a live wire
b) The Senate's secret nickname for Jesse Helms
c) One of the tantalizing new entrées on Dux's menu

Hint: it's presented atop almond bread pudding, complemented by dried apricot garnish, mustard seed barbeque sauce and ... well, we dare not continue. Just thinking about Chef McSweeny's globally-inspired creations *dux* can kick your appetite into warp drive. Dinner at Dux. It's not just a meal. It's an adventure. Open Mon thru Thurs 6 – 10pm; Fri & Sat 6 – 11pm. Reservations: 345-4540. Dux is a smoke-free restaurant.

The Peabody
ORLANDO
9801 INTERNATIONAL DRIVE

This series of ads (now numbering in the hundreds) runs opposite the table of contents in the weekend section of Friday's paper with an intelligence and wit that fosters deep loyalty among Orlando's more affluent residents.

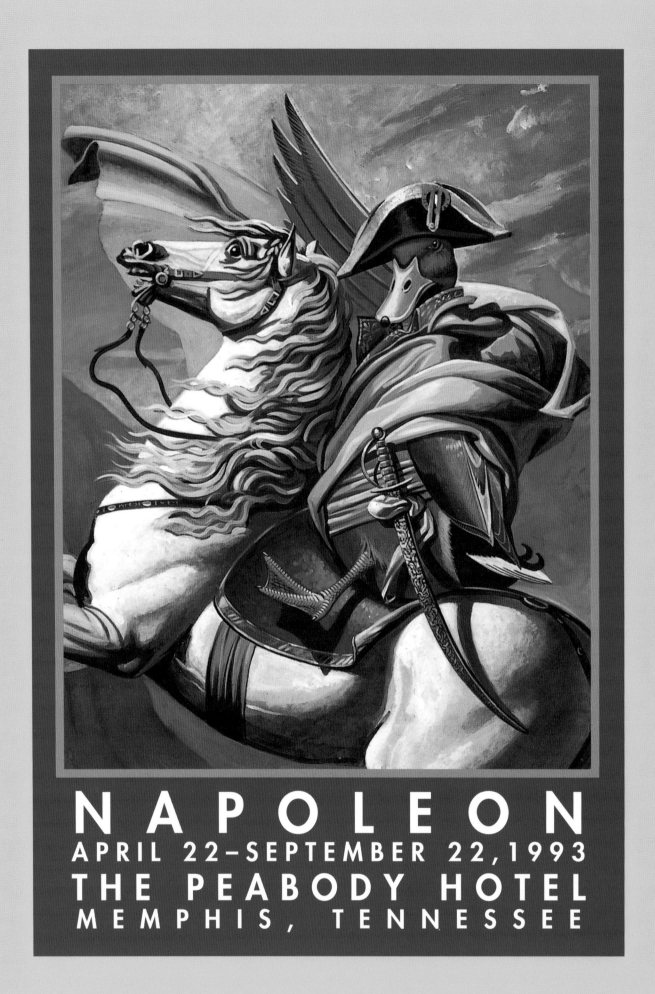

N A P O L E O N
APRIL 22–SEPTEMBER 22, 1993
THE PEABODY HOTEL
MEMPHIS, TENNESSEE

When an important traveling exhibition of Napoleonic treasures hit Memphis a few years ago, we helped The Peabody Memphis glom onto the action with this majestic, albeit totally purloined, portrait of one of the famous Peabody ducks striking Bonaparte's most famous pose. (Got a ton of press and a huffy letter from Giscard D'Estang...)

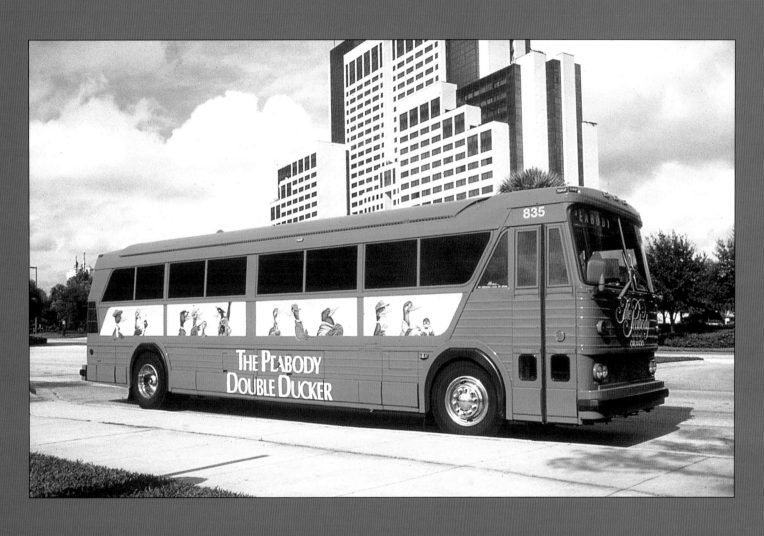

FILL 'ER UP.

It's not just the army who can help you be all that you can be.
We'll help you discover a treasure chest, shapelier legs,
a narrower waist, a re-sculpted nose, or a younger looking
face in our modern outpatient facilities.
Financing is available and all major credit cards are accepted.

Board Certified by American Board of Plastic Surgery

Premiere Center for Cosmetic Surgery
3370 Mary Street ~ Coconut Grove ~ 305-443-3370

WANNA FAT LIP?

If you weren't born with quite the pout you've always wanted,
we'll give you something to smile about.
Whether you want shapelier thighs, a re-sculpted nose,
a narrower waist or attention grabbing cleavage,
you'll get the look you want in our modern outpatient facilities.
Call for a computer imaging consultation.
Financing is available and all major credit cards are accepted.

Board Certified by American Board of Plastic Surgery

Premiere Center for Cosmetic Surgery
3370 Mary Street ~ Coconut Grove ~ 305-443-3370

PICK YOUR NOSE.

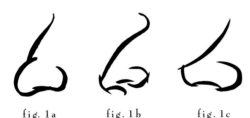

fig. 1a fig. 1b fig. 1c

If you're not happy with the nose you've got, come pick
another. And whether you want shapelier thighs, a narrower
waist, attention-grabbing cleavage or a younger looking face,
you'll get the look you want in our modern outpatient facilities.
Call for a computer imaging consultation.
Financing is available and all major credit cards are accepted.

Board Certified by American Board of Plastic Surgery

Premiere Center for Cosmetic Surgery
3370 Mary Street ~ Coconut Grove ~ 305-443-3370

WAIST RECOVERY.

Before 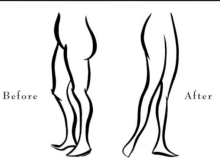 After

Spare tires belong in your trunk, not around it.
And whether you want shapelier thighs, a re-sculpted nose,
attention grabbing cleavage or a younger looking face,
you'll get the look you want in our modern outpatient facilities.
Call for a computer imaging consultation.
Financing is available and all major credit cards are accepted.

Board Certified by American Board of Plastic Surgery

Premiere Center for Cosmetic Surgery
3370 Mary Street ~ Coconut Grove ~ 305-443-3370

Petcare
Veterinary HMO

Personal Shopper

Performing Arts
for Community
and Education

BEFORE AFTER

QPQ
MEDICAL WEIGHT LOSS CENTERS
8700 NORTH KENDALL DRIVE – SOUTH MIAMI – 305/279-2325
QPQ. The shortest distance from where you are to where you want to be.

()) (

Before After

QPQ
MEDICAL WEIGHT LOSS CENTERS
8700 NORTH KENDALL DRIVE – SOUTH MIAMI – 305/279-2325
QPQ. The shortest distance from where you are to where you want to be.

136

Plenty of people need to lose weight. And plenty of firms promise a way to do it. We just had to make our promise more memorable and believable. So we took the traditional and easily understood before-and-after approach and pared it down to skin and bones. Everything from the simplicity of the layouts to the direct voice of the copy was meant to position QPQ (a relative newcomer) as the obvious leader in this field. And who but the premier provider would have the self-assuredness to show so little, and say so much, in their ads?

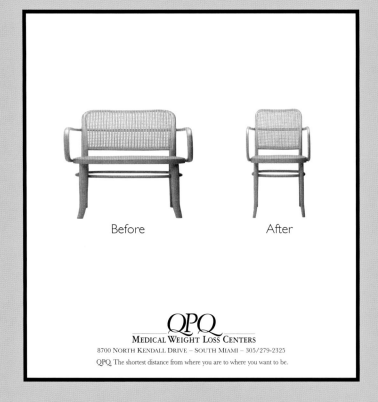

Before After

QPQ
MEDICAL WEIGHT LOSS CENTERS
8700 NORTH KENDALL DRIVE – SOUTH MIAMI – 305/279-2325
QPQ. The shortest distance from where you are to where you want to be.

**Support your community.
Give blood.**

A message from the Concerned Citizens of Boca Raton.

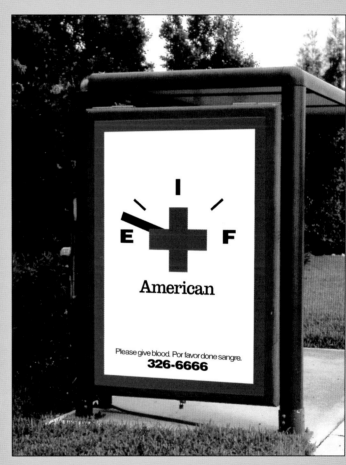

Purina
PRO PLAN

Arroz con pollo.
En vez de arroz con
misceláneo.

Siendo hasta más específico, pollo con arroz. Porque Purina Pro Plan es la única comida de mascota con verdadera carne de pollo como principal ingrediente, además de arroz y trigo. La calidad de estas materias primas beneficia la salud y la belleza de las mascotas, otorgando la mejor nutrición. Cuando usted recomienda Purina Pro Plan, sabe que recomienda lo mejor.

Purina Pro Plan. Porque los mejores alimentos siempre nacen de los mejores ingredientes.

OK. It's only a joke if you understand Spanish. But it's a good one. You see, Purina uses only 100 percent real chicken in their pet foods, as opposed to the miscellaneous meat by-products other brands include. And then there's this famous dish called Arroz con… oh, never mind. Just trust us on this one or bone up on your Español.

The Jimmy Ryce Center
For Victims Of
Predatory Abduction

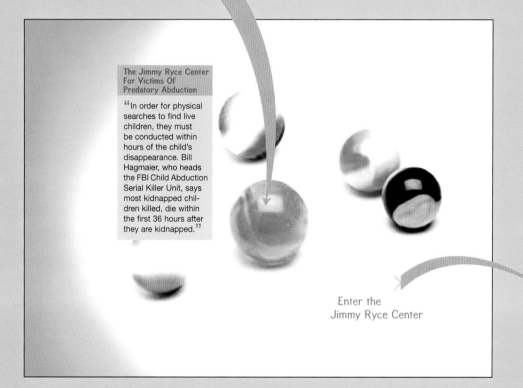

The Jimmy Ryce Center
For Victims Of
Predatory Abduction

"In order for physical searches to find live children, they must be conducted within hours of the child's disappearance. Bill Hagmaier, who heads the FBI Child Abduction Serial Killer Unit, says most kidnapped children killed, die within the first 36 hours after they are kidnapped."

Enter the
Jimmy Ryce Center

In 1995, nine-year-old Jimmy Ryce was abducted, raped, and murdered on his way home from his school bus stop. The story made national headlines and added considerably to the groundswell of public support for better means of solving — and preventing — the predatory abduction of children. We helped the cause by designing a powerful Web site for The Jimmy Ryce Center for Victims of Predatory Abduction. By sharing knowledge and synchronizing efforts, we can try to make sure such a tragedy never happens again.

Turn it over. Cool, huh?

specs

140

SWISS FINANCIAL BANK

PRECISION INVESTING

Swiss Financial, an offshore bank servicing very wealthy international customers, wanted a coffee-table book that would talk about their longevity, discretion, and international scope without actually saying anything about the bank itself. To do this, we chose European timepieces as the brain dart motif to carry our message. Why not?

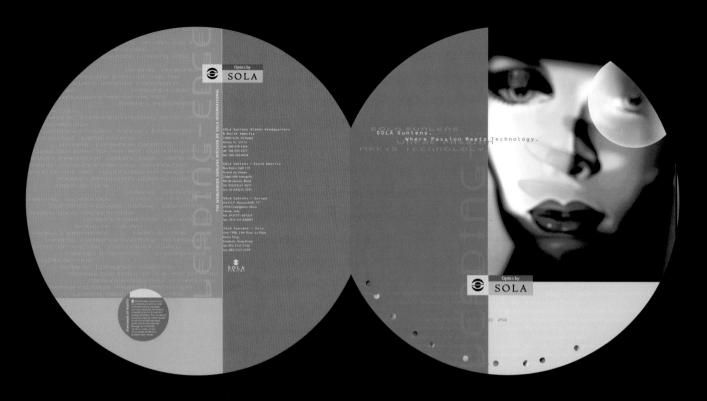

Optics by **SOLA**

SOLA Sunlens Global Headquarters
& North America
10005 N.W. 19 Street
Miami, FL 33172
tel: 800-428-2266
tel: 305-593-2327
fax: 305-592-6634

SOLA Sunlens – South America
Rua Maria Gelli 159
Chacne da Silvera
23540-000 Petropolis
Rio de Janeiro, Brazil
tel: 55(21)531-3677
fax: 55(21)531-3293

SOLA Sunlens – Europe
Via S.E.P. Marcucchelli, 17
25043 Castiglione Olona
Varese, Italy
tel: 49-0-331-691227
fax: 49-0-331-694097

SOLA Sunlens – Asia
Unit 1708, 13th Floor, Lu Plaza
Kwun Tong
Kowloon, Hong Kong
tel: 852-2337-2162
fax: 852-2337-2299

SOLA Sunlens.
Where Passion Meets Technology.

Who we are.
In 1956, nine techies were pushing a new plastic to its limits in a garage in Australia. What they came up with revolutionized the industry. Today, their innovation is known as around the world as an "optically precise hard resin" lens. OK, some call it CR39™*. And those nine guys became SOLA International. Sure, we're a really big company. But we're definitely not stodgy. We're still as innovative as ever.

*A trademark of PPG Industries, Inc.

What we do.
Everything we do, and the way we do it, must add value for our customers and the consumer. We offer the widest range of products and services in the industry, since no single product can satisfy every consumer need and preference. We're global because it makes life easier for our customers. We offer specialized edging services to provide our customers with options and convenience. We focus our innovation and technology on satisfying true consumer needs, to help our customers differentiate themselves from their competition. We talk to consumers with – and through – our customers. All of this means we work hard with our customers to do things right. With no hidden agendas. Just people, products and services our customers can trust.

Why we do it.
We're passionate about good vision. We're just as passionate about satisfying our customers. Because of this, we offer more than a bunch of products. We offer solutions. The full gamut, from marketing support to streamlined global logistics. So, when you combine forces with us, the result is awesome synergy. And a common dedication to creating consumer brand preference for high-quality SOLA lenses in our customers' frames. Because, in the end, the consumer is the focus of our customers' efforts. And as a result, of ours.

Mission
Our mission is to create added-value for SOLA and our customers by creating an awareness and belief that the quality and function of the lens, as an integral part of the branded sunglass, is critically relevant to the consumer's specific activities and lifestyles. In addition, our goal is to do all this in a way that is simple, effective and fun.

SOLA
SUNLENS

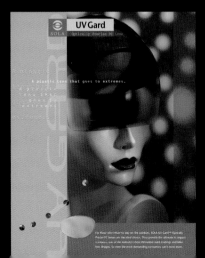

SOLA — UV Gard
Optically Precise PC Lens

A plastic lens that goes to extremes.

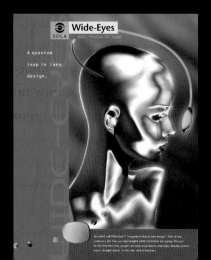

SOLA — Wide-Eyes
Full Vision PC Lens

A quantum
leap in lens
design.

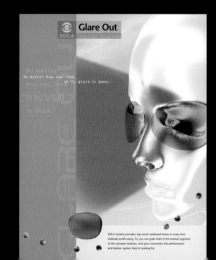

SOLA — Glare Out
Superior Polar

No matter how you look at it, glare is gone.

SOLA Sunlens provides top-notch polarized lenses in every lens material worth using. So you can grab hold of the hottest segment of the sunwear industry, and give consumers the performance and fashion option they're looking for.

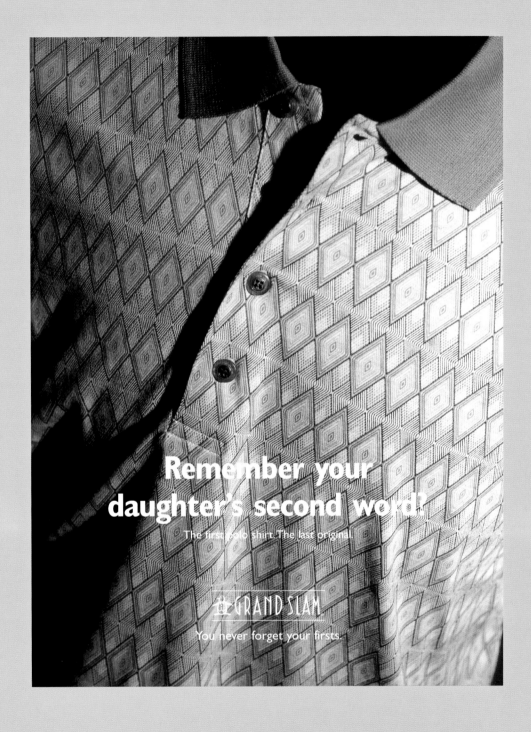

Remember your daughter's second word?

The first polo shirt. The last original.

⚜ GRAND SLAM

You never forget your firsts.

Remember the second man on the moon? Our point exactly. We took Grand Slam's most ownable position (the fact that they are the original sports shirt) and developed a campaign around it. By suggesting that you always remember your firsts, we were able to single out a product benefit and strike a chord with our audience's sense of nostalgia, while the tag line (The first sports shirt. The last original) added to the brand identity.

1. AUDIO: If you bought this gift anywhere but Sawgrass Mills...

2. ...it's not just the wrapping paper that got ripped off.

3.

144

1. AUDIO: If you bought this suit anywhere but Sawgrass Mills...

2. ...it's not just your clothes that got taken to the cleaners.

3.

1. AUDIO: If you bought this sweater anywhere but Sawgrass Mills...

2. ...it's not the only wool that's been pulled over your eyes.

3.

1. AUDIO: If you bought this stereo anywhere but Sawgrass Mills...

2. ...it's not just the batteries that got charged a lot.

3.

Wealth Food

Turbana Bananas are just right for waist lines and bottom lines.

With no artificial colorings, flavorings, or additives, they're perfect for health-conscious consumers.

And profit-conscious businesses.

What could be healthier than that? Contact your Turbana representative and find out how Turbana's health food can be your wealth food.

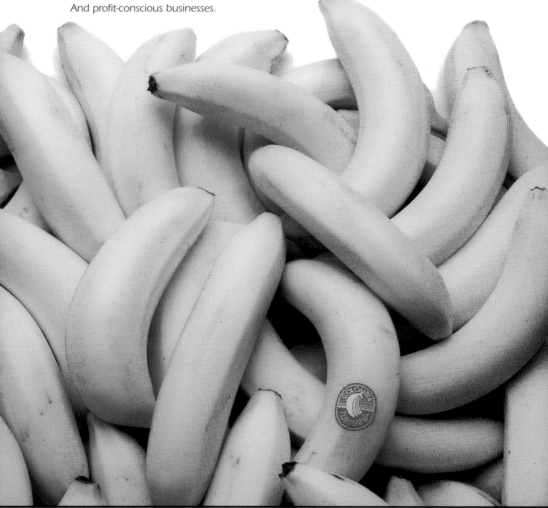

Banana Bread

Bright yellow skin. Fresh sweet taste. Nice fat profits.

That's what comes in every Turbana carton. Bunches of Bananas fresh from the tropics.

Perfect for making deliveries. Making sales. And making money.

Contact your Turbana representative and learn how fruitful our fruit can be.

How The West Was Won

Throughout the history of this country man has always sought his fortune out west.

Heading across the mighty Mississippi, the Great Plains, and onward to California.

And now, after all these years in Tampa, Newark, and Galveston, Turbana is ready for their shot.

We're expanding across the continent and opening our west coast sales office and distribution facility in Los Angeles.

We'll be shipping containers and pallets stacked with firm, fresh bananas. And laying our claim to the wild west.

Turbana. The ripe stuff.

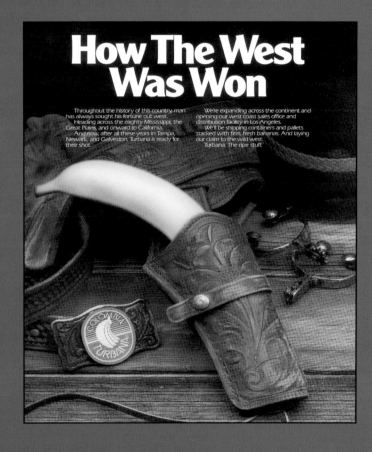

148

WE USE MANURE ON OUR FIELDS.

NOT IN OUR ADS.

Manure has its place – but this isn't it. Because fertilizer alone didn't make Turbana one of the largest banana companies in the world. It took hard work, straight talk and smart customers. Today we're still growing by making it easy for you to get just what you're looking for – great service and great bananas. So if this no-nonsense approach makes sense to you, call Turbana at 1-800-BANANAS. We'll spread the wealth, not the bull.

Not Just Bananas. Turbana.

LET'S FACE IT.

ALL BANANAS ARE BASICALLY THE SAME.

No matter what anyone says, a banana is a banana is a banana. Remove the brand label and you can't even tell the difference. What makes Turbana better is that we make your life easier. By sending you premium bananas that all look the same. The same color. The same size. The same time after time. Call Turbana at 1-800-BANANAS and see for yourself. After all, bananas are the same. Banana companies aren't.

Not Just Bananas. Turbana.

A banana is a banana is a banana. So we sold the grocery trade on Turbana's service. This elevated Turbana above the bunch, and in the nine years of our relationship, Turbana grew to be one of the top-four bananas in the world.

Turbana Bananas

Turbana Bananas

Turbana Bananas

Gloria and Bruce would like to show you their new 24-hour home entertainment system

Daniel Nathan Turkel

Born: 12/2/88 Weight: 8 lbs, 6 ozs.

This is a belated birth day card.

Aliana Melissa Turkel was born on March 30, 1994.
Her birth weight was 9lbs. 13ozs. and she was 20.5 inches long.
We've been so busy marveling over her that it took us
all this time to get her birth announcement ready.
Needless to say, she's a lot bigger now.

Ali's friends have sent her so many beautiful things that she'd like to share her good fortune.
If you'd like to wish Ali a happy birth day, please make a contribution to the
Anne Marie Overtown Community Health Center, 1550 Northwest Third Avenue, Miami, Florida 33136.
Thank you.

Knots

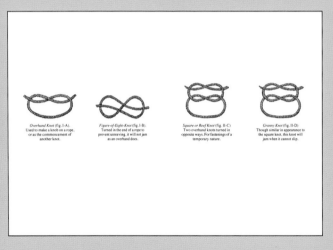

Overhand Knot (fig. I-A).
Used to make a knob on a rope,
or as the commencement of
another knot.

Figure-of-Eight-Knot (fig. I-B).
Turned in the end of a rope to
prevent unreeving, it will not jam
as an overhand does.

Square or Reef Knot (fig. II-C).
Two overhand knots turned in
opposite ways. For fastenings of a
temporary nature.

Granny Knot (fig. II-D).
Though similar in appearance to
the square knot, this knot will
jam when it cannot slip.

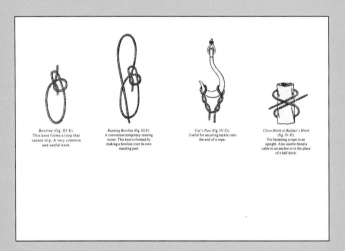

Bowline (fig. III-E).
This knot forms a loop that
cannot slip. A very common
and useful knot.

Running Bowline (fig. III-F).
A convenient temporary running
noose. This knot is formed by
making a bowline over its own
standing part.

Cat's Paw (fig. IV-G).
Useful for securing tackle onto
the end of a rope.

Clove Hitch or Builder's Hitch
(fig. IV-H).
For fastening a rope to an
upright. Also used to bend a
cable to an anchor or in the place
of a half hitch.

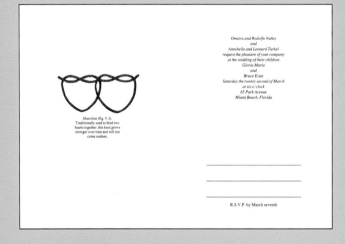

Heartline (fig. V-I).
Traditionally used to bind two
hearts together, this knot grows
stronger over time and will not
come undone.

Omaira and Rodolfo Nuñez
and
Annsheila and Leonard Turkel
request the pleasure of your company
at the wedding of their children
Gloria Maria
and
Bruce Evan
Saturday the twenty-second of March
at six o'clock
65 Park Avenue
Miami Beach, Florida

R.S.V.P. by March seventh

Technion Communications Corporation

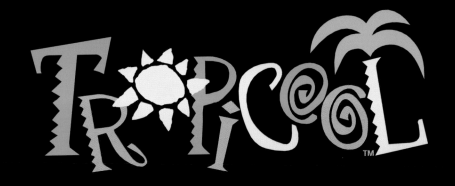

T®ADEMARKS

VISITOR
INDUSTRY
PLAN

VIP

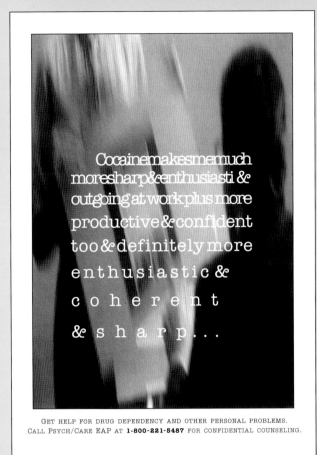

Cocaine makes me much more sharp & enthusiasti & outgoing at work plus more productive & confident too & definitely more enthusiastic & c o h e r e n t & s h a r p . . .

GET HELP FOR DRUG DEPENDENCY AND OTHER PERSONAL PROBLEMS.
CALL PSYCH/CARE EAP AT **1-800-221-5487** FOR CONFIDENTIAL COUNSELING.

Psych/Care EAP

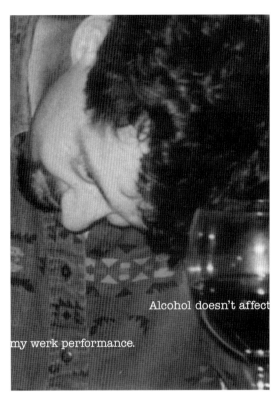

Alcohol doesn't affect my werk performance.

GET HELP FOR ALCOHOLISM AND OTHER PERSONAL PROBLEMS.
CALL PSYCH/CARE EAP AT **1-800-221-5487** FOR CONFIDENTIAL COUNSELING.

Psych/Care EAP

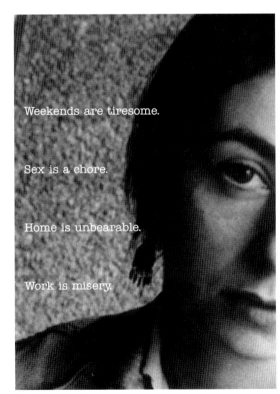

Weekends are tiresome.

Sex is a chore.

Home is unbearable.

Work is misery.

RELIEVE YOUR DEPRESSION AND OTHER PERSONAL PROBLEMS.
CALL PSYCH/CARE EAP AT **1-800-221-5487** FOR CONFIDENTIAL COUNSELING.

Psych/Care EAP

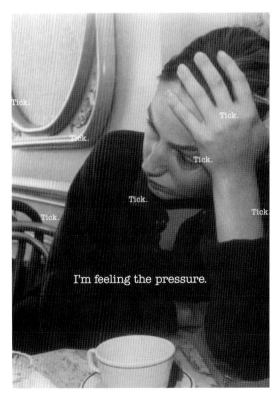

Tick. Tick. Tick. Tick. Tick. Tick.

I'm feeling the pressure.

RELIEVE STRESS AND OTHER PERSONAL PROBLEMS.
CALL PSYCH/CARE EAP AT **1-800-221-5487** FOR CONFIDENTIAL COUNSELING.

Psych/Care EAP

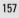

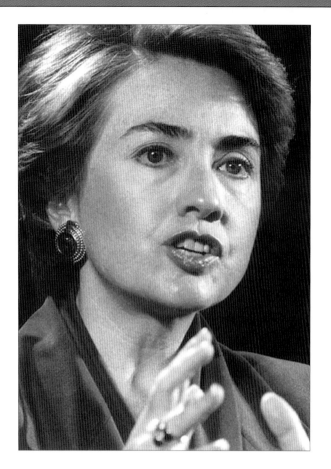

Who's afraid of Hillary Clinton?

Change can be a frightening thing. Even when it's for the better. Take the new health care reforms, for instance. While most of corporate America agrees that our First Lady's call for reform is needed, the question is how much. If you run a small-to-medium sized business, you're probably concerned about losing control of employee health care costs, as well as staying in compliance with all of these new bureaucratic regulations and policies.

But there's no need to be scared.

The reason is Vincam Human Resources.

Our out-sourcing expertise will put your mind at ease.
For more than ten years, Vincam has been the most recognized professional employer organization in this area. Our service is known as "outsourcing"—because we offer experienced human resource professionals who work full-time for your company. They'll concentrate on your employee benefits, payroll policies, compensation, labor laws and other disciplines that are confusing, and time-consuming—while you focus on running your business. Our services

can lower your costs and help your operations run more efficiently. After all, we're not providing just any human resource department. It's the kind you'd expect to find only in FORTUNE 500® companies.

Large company benefits at large company discounts.
There's no guarantee that the health care reforms will deliver all that's been promised to small businesses. That's why Vincam makes a lot of sense. Whether you have 15 or 500 employees, you'll access benefits

once reserved only for large corporations. Benefits such as multiple health options for employees, workers' compensation managed care arrangements, and more. (Just between you and us, Hillary wasn't the first to enact a radical health care system. We've been helping smaller companies enjoy large company benefits for ten years now.)

Our experts aren't hired guns.
We're not consultants—in one day and out the next. We think of it as a long-term partnership where we'll share many risks. It's a win-win situation for you. You'll have the finest human resources professionals available. Plus, our services are usually paid for by the real savings they generate. Not to mention all the time and effort you'll save.

Don't be afraid to try Vincam.
We provide all our new clients with a six-month, unconditional service guarantee. For more information, call us at (800) 741-3338. With Vincam on your side, the First Lady's reform plans will be a lot less intimidating.

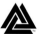
Vincam Human Resources, Inc.

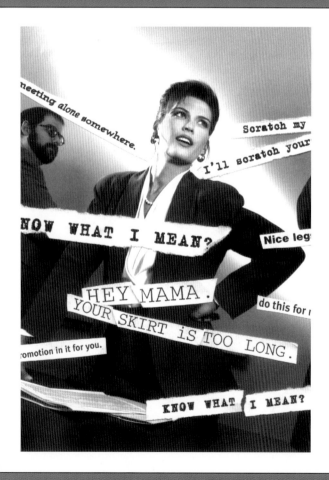

There could be a real bombshell in your company.

Sexual harassment can thoroughly destroy a company's makeup and morale. The victim is humiliated. Fellow employees become distracted, and ultimately less productive. Moreover, if brought to court, one single sexual harassment grievance could completely bankrupt a business. [In fact, the press recently reported a case award of $7.1 million.] How can you prevent this terrible act from happening in your workplace? And how can you protect your business if it does? The answer is Vincam Human Resources.

Our outsourcing expertise will put your mind at ease.
For more than a decade, Vincam has been one of the most recognized Professional Employer Organizations in the nation. Our service is known as "outsourcing." We offer experienced professionals who work full-time for you providing employee benefits, payroll, as well as establishing personnel policies, and more—so you can concentrate on earning profits. It's like having the human resource department of a FORTUNE 500® company.

Sexual harassment is dangerous to your business.
Employees guilty of sexual harassment could bankrupt you. That's why it makes sense to hire Vincam. Whether you have 15 or 500 employees, Vincam offers instruction on preventing such conduct, as well as handling and resolving sexual harassment grievances. If a complaint is filed, we'll conduct investigations and coordinate all related matters. Our goals are to protect employees and you,

as well as offer you the freedom to concentrate on core business responsibilities.

Our experts aren't hired guns.
We're not consultants—in one day and out the next. Think of it as a long-term partnership where we'll share many risks. You'll have the finest professionals available. Plus, our services are often paid for by the real savings they generate. Not to mention all the time and effort saved.

Get some protection at our free seminar.
On November 9th, Vincam will be hosting a free seminar about sexual harassment in the workplace. Get tips on what constitutes sexual harassment, how to avoid it, and how to handle a lawsuit. So plan to attend. For more information, plus reservations for our seminar, call (800) 741-3338. With Vincam on staff, sexual harassment will be less of a threat.

Vincam Human Resources, Inc.

The Vincam Group provides the human-relations services of a Fortune 500 company to smaller employers. Unfortunately, what

they do is so complicated and esoteric that it does not lend itself to fascinating, hard-hitting brain darts. To overcome this obstacle,

If you're not confused by workers' compensation, you will be when you finish this ad.

The workers' compensation system is difficult to assess because it's evolving by the day. [It will probably have changed again by the time you finish reading this.] New state laws are taking major steps towards cutting costs, as well as devising improved strategies to curb the widespread abuse. That's the good news. The bad news is you'll have to spend a lot of your valuable time complying with these new requirements. Which you can't afford to do when you're running a business. If you could attend to your employees' health care and compensation issues, without sacrificing important time and money, you'd be more successful. Fortunately, there is a solution: Vincam Human Resources, Inc.

Managed care keeps your business in good health.
For more than a decade, Vincam has been one of the most recognized Professional Employer Organizations in the nation. We offer experienced professionals who work full-time for your company helping operations run more efficiently. We provide our workers' compensation benefits through a state-approved managed care arrangement with a network of high quality providers. This allows us to control our costs effectively and ensure a high degree of coordination in promptly returning employees to work. Our system includes: supervisor training on first aid, return-to-work programs, a closely trained and monitored network of providers, fraud control programs and more. With Vincam, you'll have access to programs once reserved only for FORTUNE 500® companies.

Prevention improves productivity.
The new state laws and regulations on safety place strict requirements on your business—especially if you have a high incidence of workplace accidents. Other laws carry heavy penalties when your employees fail to return to work. This is a lot of responsibility when you're running a business. Which is why Vincam makes so much sense. Whether you have 15 or 500 employees, our turnkey system of customized safety & loss prevention programs will protect your company. It includes drug-free workplace installation and administration, on-site safety training, risk analyses and loss-control plans, plus assistance with OSHA compliance programs and more. We'll keep your business healthy and in line with the regulations—while you focus on improving your bottom line.

Our experts aren't hired guns.
We are not consultants—in one day and out the next. We think of it as a long-term partnership where we'll share many risks. It's a win-win situation for you. You'll have the finest professionals available. Plus, our services are often paid for by the real savings they generate. Not to mention all the time and effort you'll save.

Try Vincam. It's painless.
Confused? Unsure? It's understandable. To ease the transition to Vincam, we provide all our clients with a six-month, unconditional service guarantee. For more information and dates for a free seminar on workers' compensation, call us at **(800) 741-3338**. With Vincam on staff, your confusion is no longer a problem.

 Vincam Human Resources, Inc.

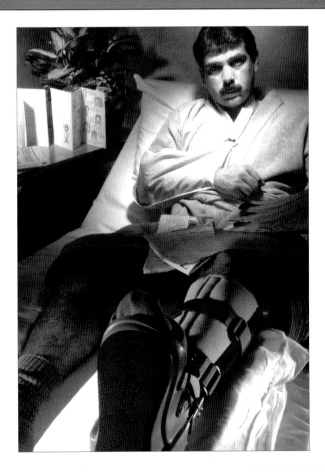

Pity the company he works for, too.

An injury in the workplace hurts the employer as well as the employee. One single injury can cost a company thousands in workers' compensation fees, medical costs, and all the lost time wages. Can you afford this? If you run a business, accidents and injuries should be a serious concern. Fortunately, there is a solution: Vincam Human Resources, Inc.

Our expertise will put your mind at ease.
For more than a decade, Vincam has been the nation's premier Professional Employer Organization. We offer experienced professionals who work full-time for your company managing workers' compensation more efficiently, providing comprehensive employee benefits packages, and administering all of your human resource concerns. It's like having the human resource department of Fortune 500® company on your side. Vincam gives you more control of your core business as well as more time and energy to generate profits. Ultimately, we give you the freedom to grow your company.

Prevention improves productivity.
Workers' compensation rates keep rising. And if an employee is injured, you could pay a heavy price. That's a good reason to hire Vincam. Whether you have 15 or 500 employees, our turnkey system of customized safety & loss prevention programs will protect your company. It includes a drug-free workplace installation and administration, on-site safety training, risk analyses and loss-control plans, plus assistance with OSHA compliance programs, and more. Our goals are to prevent injuries, closely monitor injuries that do occur, and return your employees to work quickly. Overall, we'll save you money.

Our experts aren't hired guns.
We offer you a long-term partnership—not a quick consultation. Expect only the finest professionals for your business. And realize that our services are often paid for by the real savings they generate. That's savings in time and energy, too.

Try Vincam. It's painless.
We provide all our clients with a six-month service guarantee. For more information, call **(800) 9VINCAM**. With Vincam, there will be no more suffering.

 Vincam Human Resources, Inc.

we looked for news events that business owners cared about and that Vincam's services could help them with. That way, we caught business owners' attention when they had specific concerns. And we showed how Vincam would solve their problems.

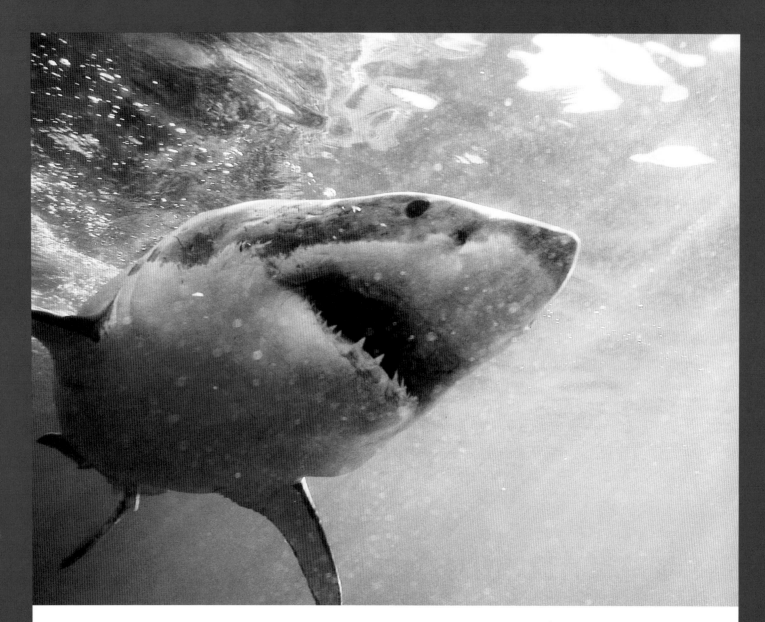

Nothing attracts lawyers faster than an employer liability claim.

Preventing and solving employer liability problems is where Vincam comes to your rescue.
As the nation's premiere professional employer organization, Vincam will work with you to ensure against employer liability claims. In fact, our human resource programs are so comprehensive and effective in eliminating lawsuits that should your company be sued, we will provide the legal defense at no cost to you.*

To learn how Vincam can help you swim with the sharks without getting eaten alive, call us at 800-9-VINCAM.

* Of course certain restrictions and requirements apply. After all, we're innovative, but we're not crazy.

Vincam Human Resources, Inc.

young ideas

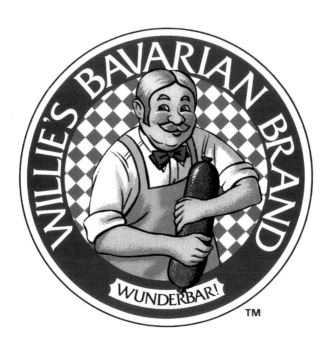

TURKEL SCHWARTZ & PARTNE

BIG IDEA | SCHMOOZE | DIGITALIA | US | BELIEVE

what's the BIG idea ?

what's the BIG idea ?

BELIEVE BIG IDEA SCHMOOZE US DIGITALIA

We've filled this web site with examples of the work we've created for our clients.

A quick explanation of the challenge they gave us.

A quick explanation of the big idea we created to meet their challenge.

And a lot of space devoted to the only thing that really matters from an agency:

The work and what it accomplished.

It can be viewed by company, industry or medium. We've also won some awards.

Believe | Big Idea | Schmooze | Us | Digitalia | Home

Copyright© 1998. Send comments to the Webmaster. The terms and conditions of the use of this site are set forth in Turkel Schwartz & Partners' Legal Page and Privacy Statement. Please read them.

B E L I E V E

YOU SHOULDN'T BELIEVE EVERYTHING YOU
READ ON AN ADVERTISING AGENCY'S WEB SITE.
INCLUDING THIS ONE.

WOULD YOU LIKE TO KNOW WHY?

CLICK THE DEPARTMENT NAME TO SEND EMAIL

PARTNERS

PUBLIC RELATIONS

ACCOUNT MANAGEMENT
MAUREEN HOWARD
director of client services

ACCOUNTING

CREATIVE

MEDIA

NEW MEDIA

PRODUCTION

SCHMOOZ

you know the way you look at advertising ?

BRUCE
TURKEL
executive
creative director

TNERS
53133-5207 USA

start over.

It's now safe to turn off
your computer.

Thanks to everyone who's been involved in all of the work we've created in the past 15 years; all our employees, clients, vendors, and friends. Of course we couldn't have done any of this without you.

And speaking of who we couldn't have done it without, this book never would have been completed without lots of dedication, talent, and support from Jennifer O'Neil, Dimitri Proano, Manny Hernandez, Christina Vino, and especially Janice Davidson and Tina Khoury. Not to mention lots of advice and support from Jennie Berliant and Shawna Mullen.

Thank you all.